CANTON'S
PIONEERS IN FLIGHT

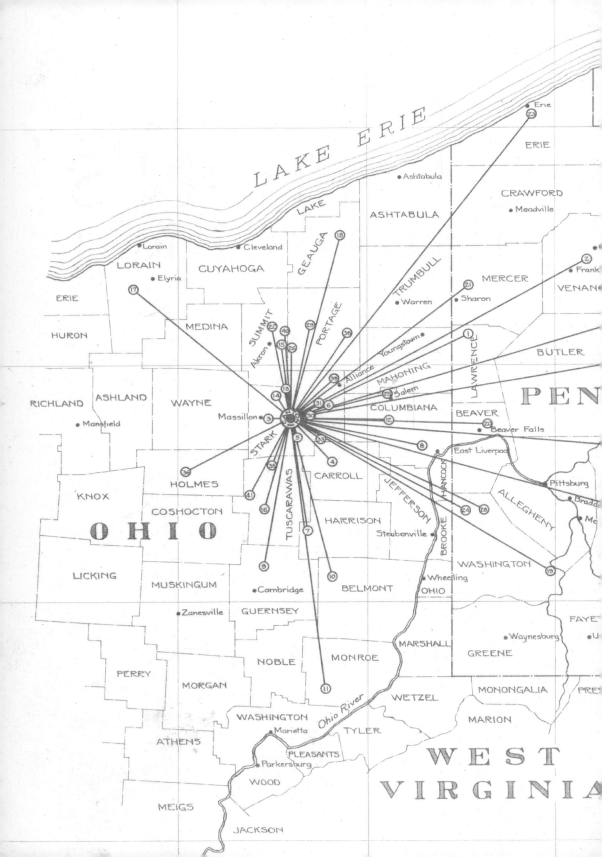

CANTON'S
PIONEERS IN FLIGHT

KIMBERLY A. KENNEY

ARCADIA
PUBLISHING

**Cuyahoga Falls
Library**
Cuyahoga Falls, Ohio

Published by Arcadia Publishing,
Charleston SC, Chicago IL, Portsmouth NH, San Francisco CA

Printed in the United States

Library of Congress control number: 2007935868

For all general information contact Arcadia Publishing at:
Telephone 843-853-2070
Fax 843-853-0044
E-Mail sales@arcadiapublishing.com
For customer service and orders:
Toll-Free 1-888-313-2665

Visit us on the Internet at www.arcadiapublishing.com

CONTENTS

Acknowledgments

After writing my first book, *Canton: A Journey Through Time*, I launched a series of outreach programs based on Canton's history. Since I touched upon aviation in that book, it became one of my topics. After giving the program for the first time at the North Canton Public Library, someone in the audience asked, "So when are you going to write a book about aviation?" And the seed was planted.

I have many people to thank for their assistance in completing the research for *Canton's Pioneers in Flight*. I was able to conduct an interview via email with Larry Lahm, son of Frank P. Lahm and grandson of Frank S. Lahm, with the help of Mary DeCanter. Cathy Allen, director of the College Park Aviation Museum, made that interview possible by providing contact information for Mary. She also sent me many invaluable articles about Frank P. Lahm, and introduced me to the Newspaper Archive, a treasure trove of information! I was also able to speak to Carolyn Caci, who was a student at Colby College and had Bernetta Miller as a house mother. Many thanks to Larry and Carolyn for sharing their personal recollections with me.

Robert Leibensperger (who retired from the Timken Company as executive vice president, chief operation officer & president — bearings) helped me access the Timken corporate archives. Terry Gamble, master technician of communications at Timken, assisted me with research about the company's fascinating connection to the aviation industry. Tim Kraft provided me with the Timken images I requested, and Jill Kolasa edited the Timken chapter.

Jim Keller provided me with charts (from Ron Armitage and E. H. Cassler) showing Martin Field and McKinley Field, and also spoke with me about learning to fly at Martin Field. Fred Krum, director of the Akron-Canton Regional Airport, spent a morning with me discussing the history of the airport. Mr. Krum's assistant Mary Lou Gartner put me in contact with Phil Gizzi, who spoke to me at length about the airport. Elizabeth Cecconi, business development specialist for the airport's marketing department, retrieved the archival images for me. Gary Brown at *The Repository* provided me with research from the newspaper's archives about Walter Wellman.

He has also written a significant number of the articles that appear in our clipping files, on a variety of topics, including aviation.

Thanks to the institutions who provided me with wonderful images: Wm. McKinley Presidential Library & Museum, Philadelphia Museum of Art, National Archives, National Air & Space Museum, and the Akron-Canton Regional Airport. (Unless otherwise noted, all images are from the collection of the Wm. McKinley Presidential Library & Museum.) I also received research assistance from the Smithsonian, Princeton Institute for Advanced Study, and Janet Metzger, librarian at the Wm. McKinley Presidential Library & Museum.

Many thanks to my family, who have offered me support and encouragement in all of my endeavors, including this book: my grandmother Marjorie Vanderhoof, my mother Cheryl Beach, my sister Kristen Merrill, and my husband Christopher Kenney, a private pilot who also served as my "technical advisor" for this project. I am the person I am today because of all four of them!

This book is dedicated to my dear friend John Bauer, who passed away in December 2006. He was a navigator in World War II and loved to talk about airplanes. He was excited that I was writing this book and was looking forward to reading it. He was greatly loved and is deeply missed by all who knew him.

1. Majestically and Buoyantly Airborne
Frank S. Lahm and the Aero Club of Ohio

At the turn of the last century, downtown Canton was bustling with activity from morning until night. Carriages clacked down Market Avenue. Businesses thrived. Stores were crowded with shoppers. Restaurant tables were filled every night of the week.

The story of Canton's aviation history begins here, in the downtown of yesterday, the center of everything in town. On the evening of December 9, 1907, fifteen of Canton's "movers and shakers" gathered for dinner at the McKinley Hotel. Johnson Sherrick, Marshall C. Barber, Gordon Mather, Zebulon Davis, George Frease, Joseph M. Blake, and others sat elbow to elbow at a table. To be sure, the men all knew each other, and their host, Frank S. Lahm. After enjoying a fine meal on that cold winter night, Lahm revealed the true reason he had asked them to come to dinner.

He said something like this: "Friends, I have not gathered you here tonight solely for the pleasure of your company. I would like to ask each of you to be charter members of the Aero Club of Ohio."

The room was likely aflutter with both excitement and skepticism. At the time, reports of the Wright brothers' experimental flights had trickled out of Dayton and Kitty Hawk, but no one in Canton had witnessed the spectacular events. Some still shook their heads in disbelief that anyone could conquer the skies. But interest in aviation was growing, and those who could not solve the "problem of flight" themselves were consumed with the idea of ballooning. The time was right for Canton to enter into this marvelous new sport.

Although Aero Clubs were sprinkled throughout the country and overseas, nothing of this kind had ever been attempted in Ohio. A club of this caliber required more than just a fascination with flight—it needed seed money. A balloon cost $1,000, a large sum in 1907, and this was probably why Lahm chose prominent businessmen from among his many friends to start this venture. Lahm's interest in flight had begun a few years before in France, after he had already lived half his life and indulged in many other passions. His influence in the aviation community was well known at the time, but he has since faded into the past. Few today

understand Lahm's impact on the course of history, or the contributions of his son, Frank P. Lahm.

Frank S. Lahm was born on April 25, 1846, and was the son of Almira Brown and Congressman Samuel Lahm, a pioneer settler, lawyer, orator, landowner, and farmer in Canton. The Lahms built a large home at 810 West Tuscarawas Street, which was later owned by Jacob Miller and John E. Carnahan. (When Carnahan purchased the home he reportedly said he had "always wanted to live in a pink house," so he had the entire building— including the brick and stone—painted that color.) At one time Samuel Lahm owned over 500 acres in Stark County, near what is now Reedurban. Tenant farmers cultivated the land and tended to the livestock, while the Lahm family continued to live in their majestic residence in the city. Samuel had come to Canton in 1836, when the tiny town was little more than a clearing in the wilderness, to practice law. A native of Leiterburg, Maryland, he was an 1834 graduate of Washington College, which later became Washington & Lee University in Lexington, Virginia. In 1837 he became Stark County prosecutor, a post he held until 1841. He was elected to the Ohio Senate in 1842 and served two terms, and in 1845 was elected to the U.S. Congress at the age of 33. Samuel went on to become a Mexican War veteran, commanding the 2nd brigade of the 6th Division of the Ohio Militia. His wife Almira, a native of New Hampshire, was related to Daniel Webster. The couple had five children—four sons and a daughter.

When Frank was nine years old, his mother became sick on a trip to visit her hometown and died shortly afterward. His father then married Henrietta Faber of Pittsburgh and had three more children. Two of Frank's older brothers, Marshall and Edward, were killed in the Civil War. Both served with the 115th Ohio Volunteer Infantry and died within three weeks of each other. Frank's younger brother Charles Henry became a wholesale fur dealer in New York City and died there in 1904. His sister Helen Rebecca married William Bowen Greenwood and spent most of her life in Canton. Little is known about the other siblings from Frank's father's second marriage. Samuel died in 1876, but Henrietta lived to be 98 years old and died in 1915. Both are buried in West Lawn Cemetery.

Frank S. Lahm often told stories about traveling with his father to visit the tenant farmers, talking about a sick sheep or other agricultural concerns. During threshing time, the workers always had a jug of whiskey on hand. In *Reminiscences of Frank S. Lahm*, written by his two children, we learn about an amusing incident in his childhood: "One day, left to his own devices, young Frank sampled the contents of a jug, then climbed up on a load of

straw and had a long, long, sound sleep! This was probably the only time in his life he took more alcohol than he could manage."

Lahm attended Canton public schools, where he read about the work of Leonardo DaVinci. Centuries before Kitty Hawk, DaVinci had designed two "flying machines" on paper, but was never able to test his theoretical machines. One was modeled after a bird's wings, and the other employed a screw mechanism reminiscent of a modern helicopter. He would have needed an engine to make his machines take flight, but in DaVinci's time nothing of the kind was possible. These wild ideas captured the imagination of a small Canton boy, who became infatuated with the idea of flight.

After completing his schoolwork in Canton, Lahm took a business course in Pittsburgh. He formed a partnership with Michael Harter, George D. Harter's brother, and opened a hat shop in Mansfield. Soon he became smitten with local gal Adelaide Way Purdy and married her in February 1875. A family friend once said, "When she entered a room, it was like a ray of sunshine coming in." The couple had two children, Katherine Hamilton and Frank Purdy Lahm. Not long after their wedding, impaired health forced Lahm to give up business. At the urging of his physician, he began traveling the country in search of a suitable climate in which to recover. Whenever possible, Adelaide traveled with her husband, leaving the children in the care of relatives in Mansfield. Finally, Lahm returned to Canton with his family to live in the home of his sister Mrs. Helen Lahm Greenwood, next to the Presbyterian Church.

Local doctor Lorenzo Whiting put Lahm on the "Dr. Salisbury beef-diet treatment," named for the man who invented Salisbury steak in New York. The meat was in a much refined form when given to patients in Lahm's condition, with all fibers and gristle removed. But nothing seemed to work, and his health did not improve.

After only five years of marriage, Lahm's wife died unexpectedly in 1880 after giving birth to their third child, who also died six weeks later. Friends were shocked, believing that it was Mr. Lahm who died, not Mrs. Lahm, who had been in perfect health. He was too ill to attend her funeral services in Mansfield. Heartbroken, and with his health worsening, doctors suggested he change his scenery completely and travel abroad. Katherine, who was then four, stayed with her Aunt Helen in Canton, while two-year-old Frank P. went to live with his mother's sister, Mrs. Mary Purdy Weldon, in Mansfield.

Lahm sailed for Europe on October 20, 1880 on the French steamer *Labrador*. His condition was so dire, friends assumed they were saying their

final goodbyes, as he surely would never return to his native shores. After the 13-day voyage, he arrived in France. To everyone's surprise, his travels greatly improved his health. He stayed in the south of France, Italy, and Switzerland, where he took up mountain climbing. He quickly regained his vitality. On August 8, 1881, he climbed 14,782 feet to the summit of the Matterhorn, when just 10 months before he had been bedridden. He also went to the top of several other mountains, including Mont-Rose and Breithorn.

Shortly after his monumental climb, Lahm settled in Paris and became the European agent for the Remington Typewriter Company, a job he would retire from 25 years later. He introduced American typewriters to European markets. Initially he had planned to stay for only six months, but soon fell in love with Europe in general, and Paris in particular. "There was leisure in the Paris of 1881," Lahm once wrote. "The elegance of the Second Empire still hung about."

Here Lahm indulged in his first love, art. He often joked there was not a major exhibition in Paris for 50 years that he had not seen. He believed he had seen more "good pictures" than anyone else in the world, and kept a detailed list of the museums and galleries he visited. He met several prominent artists and became an amateur collector. He was enchanted with the work of Auguste Ravier, who became one of his favorites. Ravier was known for painting glowing sunsets. When Lahm discovered his work, the artist had recently passed away, but Lahm traveled to his home to meet his widow and daughter. He cultivated a relationship with other Ravier collectors, and amassed the largest private collection of his work. "I remember my grandfather's apartment in France had many paintings on the walls," recalled Larry Lahm. "I was surprised to see many paintings stacked in the closet."

In the 1910s, Lahm organized an exhibition of over 150 English war posters, French artistic posters, and Dutch, Spanish, and Italian posters to be held at the T. K. Harris building in North Canton. A circular advertising the show stated, "Mr. Lahm says he was unable to procure any German or Russian posters, owing to war conditions." Harris donated the space, but Lahm covered any additional expenses himself. The English posters apparently showed how the country was able to raise an army of three million without a draft. The brochure further described the rest of the show:

> Many of the French posters were designed years ago by some of the greatest artists of the times. They are sought for by collectors.

Taken in comparison with those of the other countries, they offer an excellent opportunity, for anyone interested in art, to judge artistic expression according to nationality, and to business men to get indications for future advertising.

According to the brochure, all of the proceeds were to go to charities, both in Canton and in France: "It is proposed to divide the receipts between French wounded soldiers, and especially those who have lost their eye-sight through the war and three Canton charities: the Aultman hospital, Mercy hospital, and the charitable committee of the D.A.R."

Lahm's love for France and devotion to his hometown co-existed within him all of his life. He spent as much time as he could with his children, both here and abroad. Both grew up with a keen understanding of their father's devotion to them, although he was separated from them most of the time. He wrote to them often, and always mentioned the other child, to keep the three of them connected, though they did not live under the same roof. As soon as they were old enough, Lahm had each child spend a year in boarding school in France. They spent weekends and vacations with him in Paris, or went on trips together. But Lahm wanted them to have most of their education in the United States and grow up as Americans.

Despite his love for France, Lahm returned nearly every year to his home on Turkeyfoot Lake, north of Canton in Summit County. He had "discovered" it in 1876 while horseback riding with Charles Pendleton, a friend from Akron. "He described it as the most beautiful spot he had seen," wrote his son Frank P. in a letter to the Stark County Historical Society in 1960. "The following year he purchased the property." He always looked forward to seeing old friends at Turkeyfoot Lake. Indeed, Lahm never forgot his hometown. He even maintained a lifelong subscription to the Canton *Repository* while living in Paris.

Lahm recorded each of his ocean voyages in a small leather bound journal, noting such details as the cost of passage, what his room was like, and how long it took to reach his destination. He also kept track of how many times he had made the journey, with comments like "my 50th crossing of the Atlantic, passage $157," which he wrote in 1930.

While living in Paris, Lahm became interested in the activities of the French Aero Club. The French were on the forefront of aviation technology and had a well-established organization of enthusiasts dedicated to the sport of ballooning. In 1902, Lahm missed his first opportunity to go up in a balloon, because he did not have 250 francs (about $50) at the time.

Later in the year, during a membership drive, the club offered a special on ascensions for just 50 francs. Lahm made his first ascension on September 25, 1902, from the Aero Club Park at St. Cloud, outside Paris. At the time, he was already 56 years old.

"From boyhood I wanted to make an ascension," Lahm told *The Repository*, "and for this reason I joined the Aero Club of France. I took up ballooning as a pleasure, a mental recreation, for the sport there is in it. The Club, however, has a more serious purpose than the narrow one of sport. In the study of atmospheric conditions and air currents, it is doing a valuable work. After my first ascension I became an enthusiast which is almost always the case." After joining the club, Lahm purchased his own balloon, which he named *Katherine Hamilton* after his daughter. After 13 ascensions he qualified for his pilot's license in November 1904. He wrote in his flight log, "This is the ascension alone which gave me my pilot's certificate. Number of ascensions required at the time—ten, but this is my thirteenth—best landing I ever had." He became a member of the club's executive committee in 1906 and served until his death in 1931.

Lahm threw himself into France's aeronautical goings-on. In 1907 he was appointed representative for the Aero Club of America at the Brussels Conference of the International Aeronautic Federation. He later became vice-president of the IAF and attended all of their meetings in grand cities like Rome, Prague, and Madrid. While in Spain, he once had the opportunity to shake hands with the king and queen.

In addition to being a recreational pursuit, the object of all the aero clubs was to make ascensions as high, far, and long as possible. One way to add to the sport was to hold international competitions.

By this time, Lahm's son Frank P. had graduated from West Point and was a lieutenant in the U.S. Army. Most likely because of his proficiency in French, no doubt influenced by his exposure to foreign languages at an early age, he had been assigned to the famous French Cavalry School in Samur for the term beginning in October 1906. In 1904, Lahm had taken his son up on his first balloon flight, writing in his flight log, "Frank's first ascension—a bad night—landed in the rain—completely dark—and dragged some distance." In the summer of 1905, Frank P. earned his balloon pilot's license.

Lahm had previously accepted an invitation to participate in the Gordon Bennett Cup in 1906, the first international balloon race, as one of three representing the Aero Club of America. James Gordon Bennett, principal owner of the *New York Herald*, presented a silver trophy to the Aero Club of

France to award to the winner of the race. The winning club would "own" the trophy until the next year's race. Lahm was reportedly instrumental in getting the newspaper magnate to sponsor a cup for the winner of an international race.

Lahm was already 60 years old, and his health was not up to the grueling competition, so he asked his son to compete in his place. Intense training sessions began. Father and son spent many hours making practice flights, totaling 14 before the start of the race. The younger Lahm chose Major Henry Blanchard Heisey as his aide. Heisey had experience with the U.S. Weather Bureau and had been studying storm tracks and prevailing winds in northern Europe, which was valuable knowledge for piloting a balloon.

A total of 16 balloons participated in the race, representing seven countries, most of which were interested in ballooning for military purposes. Most balloons had at least one officer either as the pilot or aide. Each pilot drew a number to determine the starting order, with teams departing at five minute intervals. An Italian team drew the first number and started at 4:00 p.m., as Bennett himself pulled the trigger on the starting gun. Frank P. drew number 12 in the race and started 55 minutes later. On a gorgeous Sunday afternoon, the balloons began to rise from Tuilleries Garden in the heart of Paris on September 30, 1906.

All drifted westward with the prevailing winds. After two hours, there were only four other balloons in sight. As the sun went down, they each disappeared one by one. By 9:30, Frank P. couldn't see any. Before 11:00, they passed Lisieux. Seventeen minutes later they crossed the English Channel. "With a full moon shining overhead," said Frank P., "an almost cloudless sky, the balmy air and, except for the gentle breaking of the waves beneath us, not a sound to disturb the perfect calm, nothing could be more charming, nothing more delightful." At 2:30 a.m. a light appeared in front of them, which was a lightship off the English coast. "Then the friendly moon deserted us," Frank P. said. "The mists began to rise and the earth disappeared. It gave us an uncomfortable, an uncanny feeling." The thick fog began to break up as the sun came up, but they still could not see the ground. They began to call out to the people below, trying to get some information about their location. No one heard them until after 7:00, when they discovered they were over Berkshire County.

As they traveled north, the sun began to warm the gas in the bag, increasing their altitude. By 2:00 that afternoon, they were holding steady at 10,000 feet. They descended gradually to avoid an eastern drift that would have brought them out over the North Sea. They expected to head toward

Scotland, but were suddenly driven toward the ocean. They decided to land in the English countryside at 3:12 p.m.

Local residents helped them pack the balloon for shipment back to Paris and they boarded a train for York. Since they had not slept all night up in the balloon, both men retired early. It wasn't until the next morning they learned they were ahead of all the teams who had reported in. One team had not yet been heard from. It wasn't until late that afternoon, after reaching London, that word came that they had been declared the winners. It was certainly a boost to national and military pride when an American army officer won the first international balloon race.

Having heard nothing about the outcome of the race, his father sent a wireless message from his ship, which was crossing the Atlantic en route to his daughter's wedding. It read, "Winner and son's place?" The reply to both questions came in one word—"First." Lahm replied, "Bravo." He was later quoted as saying, "It was the surprise of my life when Frank won the international race. I had no idea the boy's nerve would keep him in the air as long as he was. I thought, of course, he would make a good journey, but I did not look for him to keep it up the way he did."

Winning the first international race was the first step in a lifelong love affair with flight. Ballooning, according to Frank P., was "one of the greatest sports in the world." He described the experience in a *New York Herald* article in July 1911:

> It calls into play every faculty of the body and mind. While it is true that it makes no violent demand upon a man's muscular system, he who is not strong and healthy should not undertake an extended flight. . . . You encounter sudden and great changes of temperature. Rain and snow, cyclones and storms of thunder and lightning; great oceans of fog that blot out the world as completely as if it had dropped out of space . . . blistering rays from the sun that can cause you to ascend as if from a catapult, and then waves of icy air that make you drop like a plummet. . . . When the day is bright and cool and the air a drifting sea of balm, floating over the country at a height of two or three thousand feet gives a man a feeling of exhilaration and elevation of the soul and mind that nothing else affords. There may be intense joy in driving in an automobile race, in running a marathon, in riding in a steeplechase and in other sports on land and water, but in my experience the joy of these sports is

lost if the victory is lost. Not so in ballooning. Win or lose, you have your delight.

Following his son's triumph, Lahm wanted to share his love of ballooning with his friends back home in Canton. After announcing his intentions to form a club to his assembled friends at the McKinley Hotel, Lahm said, "Gentleman, now that we have an Aero Club, we must have some balloon ascensions, and I want to tell you that while I was in New York, I had some conferences with Leo Stevens, who is the leading aeronaut in the United States, and he has agreed to ship a balloon to Ohio and come out and arrange a flight."

And so the Aero Club of Ohio was born.

Eventually the group purchased its own balloon, and christened it *The Ohio*. When it was not in use, it was kept deflated in the basement of the Courtland Hotel. One can imagine the excited members of the club going down into the basement to retrieve their balloon, ready for the next adventure ballooning would bring them.

Industrialist Gordon Mather and attorney Joseph Blake applied to go on the first flight, with Lahm as pilot. On December 20, 1907, a crowd of over 10,000 congregated at the corner of Walnut Ave and 7th Street SE. Contemporary reports said, "They jammed nearby shop roofs and freight cars and many leaned out of windows of nearby homes."

The balloon was filled with 35,000 cubic feet of gas in a large vacant lot near the old Canton Gas Works at the end of Walnut Street. *The Repository* writer Lester McCrea recalled the story of that day in a 1953 article:

> The tethers holding the huge bag were loosened. A stray draft caught the balloon and the bag crawled slowly to the west for a few feet. It then became airborne "majestically and buoyantly" as the *Repository* of that day reported. Suddenly the crowd gasped. The balloon was coming perilously close to the roof of the nearby Biechele soap factory. Would it make it? Lahm hurriedly dumped sandbags used as ballast. The basket narrowly missed the edge of the roof, picked up speed and height and soon was just a speck on the horizon. And that was man's first conquest of the skies from a Canton base.

That day was a milestone in Canton's history. The story made the front page of *The Repository*, and several photographers were there to capture the

moment for posterity. Lahm recorded the event in his flight log, which shows that the group ate lunch in the air two miles south of Alliance. At 3:15 they crossed the Ohio state line at the Mahoning River. *The Repository* published two "extras" reporting on the search for the balloon. Finally at 7:11 p.m. a Western Union message arrived from Lahm: "Landed three-forty, eight miles north of New Castle. Beautiful trip. See you soon." Lahm also wrote the following in his log book:

> The first ascension of the Aero Club of Ohio of which I was the founder . . . Our first ascension was a fine one—there was snow on the ground after landing on a farm two miles south of Pulaski, Pennsylvania, we went to the station in a sleigh. We passed right over Osnaburg, Mt. Union, Salem and could just see the smoke of Youngstown to the north.

A second balloon flight was scheduled for January 23, 1908, but was postponed for five days due to snow. This time Lahm's son Frank P. piloted, with J. G. Obermeir and Herbert W. Alden as passengers. Orville Wright came from Dayton to witness the ascension. This flight did not go as smoothly as the first. An article in the January 29, 1908 edition of the *New Castle News* (New Castle, Pennsylvania), reported what happened:

> When the balloon was ascending at Canton it became enmeshed in telephone wires and the grappling hook caught on a telephone pole and was lost, thus making safe landing more difficult. Just before the attempt at ascension, Lieut. Lahm, the aeronaut, had been almost axphyxiated [*sic*] beneath the gas bag and it was only the fortunate circumstance resulting in his being found in the nick of time that saved him from death. After having been restored to consciousness he rapidly recovered and this incident only delayed the ascension a few minutes.

The people of Canton anxiously awaited word from the balloonists. *The Repository* sent inquiries over the AP wire requesting information about the whereabouts of the balloon. The New Castle paper reported on the scene from their perspective:

> It was about 3 o'clock Tuesday afternoon that a telephone message was first received at The News asking that a careful

lookout be kept for the big gas bag. About 4 o'clock another anxious Cantonian asked if anything had been heard and was informed that no word had reached this office. Just a few minutes after a telephone message was received from the vicinity of Struthers stating that the balloon and its occupants had been seen sailing over that town and that a couple of sand bags had been thrown out in order to lighten the balloon so that it could pass over the hills and the trees higher up.

People from Canton repeatedly called the *New Castle News* office throughout the night, hoping to hear where the balloon had landed. Since the takeoff had been rather difficult, everyone feared that their luck would not hold out and "some accident had befallen them." They later learned the balloon had reached an altitude of 6,930 feet, and had landed "at great peril" in mountainous country at Sandy Hill, 12 miles from Oil City, Pennsylvania. Most likely because the grappling hook had come off during their rough takeoff, during the landing the wind dragged the basket 150 feet over the rocks before it was stopped by some trees overhead. In total, the balloon had traveled 100 miles in two hours and 15 minutes. Perhaps waiting for better weather, the next balloon launch was not held until June 6. New York balloonist Leo Stevens piloted, with Dr. and Mrs. H. W. Thompson of Salem as passengers. Many other ascensions followed that summer, with various club members earning their own pilot's licenses.

As president of the Aero Club of Ohio, Johnson Sherrick was invited to the second annual banquet of the Aero Club of New York on March 27, 1908, at the Hotel St. Regis in New York. Over 100 balloon enthusiasts gathered that evening. Sherrick found himself seated at a table with legendary individuals, including Professor Alexander Graham Bell; Wills L. Moore, chief of the U.S. Weather Bureau; and none other than Lt. Frank P. Lahm, who was representing the Signal Corps. Most of the men probably knew each other, if not personally then at least by reputation. For example, Professor Bell had often invited Frank P. Lahm and his colleagues to his home to discuss many topics, particularly aviation.

Sherrick was often chided for holding the highest office of the club and yet never making an ascension. Finally, he went up on July 23, 1908, at the age of 67, much to the excitement of the gathered crowd. He could be seen bowing and doffing his cap as the balloon went higher and higher. The wind was extremely calm that day, and the balloon slowly zigzagged across the sky for two hours, landing in North Industry.

Balloons named *Sky Pilot, All America, You and I,* and *The Buckeye* also ascended from Canton. Multiple balloons meant the Aero Club could hold balloon races, which were held in 1908 for Labor Day and in 1909 as part of the Stark County Centennial festivities. Stark County Historian E. T. Heald told the story of the first race between the *Sky Pilot* and the *Ohio* on September 7, 1908:

> The start of the race was without incident, but incidents soon came. At first the occupants of the "Ohio" were so interested in locating the spot where Johnson Sherrick had landed a few miles below town, on his flight a short time previously, after standing still in the air a good part of the afternoon, that they did not notice that the balloon had struck a cold current and was headed down fast, straight towards the roofs of the houses in North Industry. On orders from the pilot, the sand in all the ballast bags except one, were dumped over fast; but the momentum was so great that there seemed no escape from hitting a roof, when the balloon suddenly stopped and began to sway up and down. The welcome miracle was unexplained until it was observed that the end of the trail rope which hangs from the balloon two or three hundred feet, had wrapped itself around the cross bar of a telephone pole. There the balloon hung, until somebody down below climbed the pole and cut it loose. With the balloon light from the loss of all the sand, it lit out at high speed for the sky, soon thrust through the clouds and soared high to a height of around 12,000 feet. At that height, there was nothing to impede the warm rays of the sun which soon inflated the gas and the balloon swept into Belmont County, nine miles south of Piedmont, Ohio, where the setting sun cooled the air and the balloon descended. . . . It finally came down in a large open field, aimed straight at a bunch of horses, which scampered away at a great rate, as the pilot pulled the rip cord and the balloon hit the ground.

The balloon proceeded to jump back up into the air, hop over a fence, and land sideways in a blackberry patch. Ballooning was an inexact science, and many Cantonians faced rough landings at the hands of Mother Nature. Incidentally, the *Ohio* won the race against the *Sky Pilot,* which landed on a farm five miles east of Kimbolton in Guernsey County.

The club continued to sponsor ascensions, with another 16 trips recorded in 1908.

Participants in the Aero Club's activities marveled at the freedom that flying in a balloon offered them. It is difficult to imagine in today's frequent-flyer world how seeing the Earth from the perspective of the clouds for the first time would have affected those fortunate enough to ascend in a balloon. Although the club made many ascensions, only an exclusive number of people actually had the opportunity to do so. Pilot Leo Stevens took Canton's first female balloonist, Gladys Tannehill, up in the *Sky Pilot* on September 24, 1908, landing near Cairo, Ohio. After a solo trip in *You and I* at a later date, she said:

> My trips were such short ones. I want to fly a long distance, go skimming though the clouds like lightning. It's certainly no fun to hang over the city and see the same sights for a half hour at a time. Canton girls do not know what fine sport it is, or they would be more eager to go. Many girls have told me they were ready for a trip, but none of them come forward. Maybe they are afraid. That's foolish, for a girl doesn't have to be so very brave to enjoy every minute of a journey.

Later a second Canton woman took to the skies in a balloon. After her first ascension with her brother Charles, Blanche Vignos, who was president of the Ohio Federation of Women's Clubs, said, "It was so calm and beautiful that my only emotion was of delight." She declared that after her balloon ride, all other forms of travel had lost their charm for her. In September 1909, Sherrick wrote an article for *The Repository*, saying, "Women have experienced the sensation of air flight and, as men, pronounce the sport exhilarating and even superior to automobile riding. We in Canton know ballooning and appreciate it."

Sherrick also described how well known the club had become: "Few of us realize that The Aero Club of Ohio, which at its birth was looked upon as a joke, is now spoken of in every aeronautical center of the world." He reported that in Paris, they were discussed as one of the "most enterprising organizations of aviators in existence. . . . The number of our flights usually exceeds those of every other club in the country." He also said prominent aeronautical journals of the time were writing monthly reports about the activities of the club.

Most ascensions went off without incident, but there are a few stories of minor trouble on some flights. For example, on December 5, 1908, Dr.

H. W. Thompson piloted the *Ohio* with W. J. Fornes and Louis Brush as passengers. Originally, the trio had planned their ascension for a beautiful fall day, but strong winds prevented them from going up. Dr. Thompson ordered that the balloon be deflated, wasting $46 worth of gas. The three were incredibly disappointed and had to wait several weeks for another opportunity. Finally, after a heavy snowfall, conditions were right for flying in a balloon.

At first, the flight was rather uneventful. But when they reached Salineville, the wind completely disappeared, and they found themselves in a dead calm. The balloon floated so low in the sky, they could talk to people on the streets. It was probably the first time anyone in that town had actually seen a balloon with men in it meandering across the sky. They dumped ballast to no avail. As Fornes recounted years later in the September 5, 1948 issue of *The Repository*:

> Just as they were preparing to descend, a wind sprang up and made up for lost time. The balloon was whisked away quickly and when they had reached Carnegie, PA, Dr. Thompson decided to come down. Each member of the crew of three had special duties. Mr. Fornes was in charge of the ballast, Mr. Brush handled the anchor and Dr. Thompson was in command and manipulated the valve which released the gas. The skipper of the bag had spotted what looked like a good landing place and operated the valve so skillfully that it settled in the spot he had selected. It turned out, however, to be a steep hillside covered with tree stumps.
>
> Mr. Fornes threw out some ballast to go up again but Mr. Brush was a little slow in bringing in the anchor and it caught on the eaves of a farmhouse in which the family was eating supper. The farmer folks dashed out to see what the commotion was about. The anchor had pulled loose, bringing a piece of the cornice with it, the balloon passed over the roof of the house and the anchor snagged again in a big apple tree, bringing it down with a crash.
>
> By that time Dr. Thompson had released more gas and the big bag settled to the ground and the occupants jumped out and made it fast. The farmer was too enthused to be mad about the damage to his house and tree. He and his two husky sons helped the airmen roll and pack the balloon. Then they got

out a bobsled and hauled the airmen and their equipment to the nearest railroad station for the trip back to Canton. For everything, including property damage, they received $5.

On the way to the railroad station, Brush talked nonstop to the fascinated farmer and his sons, prattling on about the adventures of ballooning. When he got a chance, Brush leaned over to Fornes and whispered, "Maybe if I talk fast enough, I can make them forget we tore off the corner of their house!"

Another flight that didn't go according to plan happened on September 27, 1909, with Frank P. Lahm piloting and W. R. Timken and Joseph Blake as passengers. Both Blake and Timken were slightly deaf, and didn't hear the pilot's request to throw the balloon cover and bags overboard when there was no more ballast to release. Although it was not as spectacular a stunt as felling an apple tree, the trio found themselves landing in the woods, hitting a butternut tree that showered them with nuts!

Part of the club's festivities included an annual dinner, held each year at a posh restaurant in downtown Canton. The first dinner was held January 28, 1909, at the Courtland Hotel, one year after Lahm had gathered his friends at the McKinley Hotel. The menu included whimsical dishes, named in honor of the club's members and activities, including: Hors d'Oeuvres Aero-Club, Potage Tomato Sherrick, Crabbe en Aeroplane, and Pommes de Terre a la Sky Pilot.

Lahm was incredibly proud of his hometown club's accomplishments. He commissioned a map to display at the aeronautical exposition in Paris showing the routes and landing places of all ascensions made from Canton. Many of the flights made national headlines, including Dr. Thompson's solo flight in April 1909, which even made the *New York Times*. Thompson had flown 90 miles from Canton to Bulger, Pennsylvania, which would have been a 125-mile trip by road. Once on the ground, he wired Sherrick that the "voyage had been a rough one," but the solo flight qualified him for his pilot's license.

Club members often traveled to other cities to participate in the balloon activities of other clubs. On September 18, 1910, the *Indianapolis Star* headlines read: "13 Gas Bags Entered from Many Points Throughout Country Sail from Speedway." *The Buckeye*, piloted by J. H. Wade of Cleveland and A. H. Morgan of Canton, was at the meet. The article reported great interest in the surrounding communities. Soldiers near Fort Benjamin Harrison even halted maneuvers and kept a lookout for balloons with the aid of their field glasses.

In 1910, the names of 20 members who planned to make ascensions were published in *The Repository*. Each person would pay $15 for his flight. This would be the last year of ballooning in Canton, as club members shifted their attention to "heavier-than-air" flight. In a May 1910 letter from France, Lahm suggested that his friends begin to refocus on the new "aeroplanes" that were making a splash in the media. As early as 1909, Lahm had promised a $250 prize for the first club member who flew a heavier-than-air machine for one mile, straight or in a circle, taking off no more than three and a half miles from the courthouse in downtown Canton. After just three years, an important chapter of Canton's aviation history had come to a close.

Though the club no longer sponsored balloon ascensions, the group continued to support aviation activities in Canton. Following Lahm's advice, the Aero Club organized a spectacular aviation meet in September 1911 at the Stark County Fairgrounds, comprised of 40 acres of space for aerial feats. It was the first major flying show in Ohio, and according to *Repository* writer Lester McCrea, it was "the forerunner of the barnstormers and aerial circuses which were common in the 1920s." Several major names were scheduled to appear, including Harry Atwood, who gained national fame flying from New York to St. Louis in a Burgess-Wright machine; Walter Bookins, who flew a late model Baby Wright; Eugene Ely, who set speed marks in his Curtiss biplane; and Jesse Seligman, who flew a Moisant monoplane with an Anzoni engine. Frank P. Lahm was one of the judges for the flight contests and races, which included speed events, quick starting and stopping near designated spots, altitude flying, quick climbing, and bomb-carrying contests. Dirigibles and balloons were also featured.

Aerial meets were as exciting as they were dangerous. There had been some fatalities at the Chicago meet in August 1911. A plane piloted by Pittsburgh native William R. Badger plummeted 100 feet to the ground, breaking his neck and killing him instantly. A flaw in the propeller was blamed. He had crashed in front of the main grandstand. St. Crois Johnstone of Chicago plunged into Lake Michigan, with his young wife looking on in the audience. He was caught under the heavy engine and drowned before rescue crews could get to him. Despite the tragedies, officials decided to continue the show, saying the other aviators were "unshaken" by the crashes.

Canton's aviation meet one month later was heavily promoted and drew a crowd larger than the population of the city at the time. It was reported in newspapers across the country. Special excursion trains from cities around Ohio brought thousands to town. *The Mansfield News* in Mansfield, Ohio,

reported just before the show that "special rates have been offered by the Pennsylvania lines and one large Mansfield firm is particularly interested in the meet as an advertising novelty." More than 65,000 people attended: 24,240 came on the first day and 40,000 attended the third day. Due to rain, the second day's crowd was kept to a modest 1,500. New bleachers were constructed especially for the meet, and more than 250 special deputies and militiamen commanded by Harry Hazlett were hired to control the crowds. A local committee guaranteed $15,000 to the show's promoters. The committee included well-known names like Charles A. Dougherty, Joseph Blake, Johnson Sherrick, and others.

The Newark Advocate heralded the Canton meet as the third international meeting of "birdmen" in the United States, with previous shows in the large cities of Chicago and Boston. The article said Canton was chosen for the meet "principally on account of the international fame of that city as a balloon center." There was reportedly $50,000 in prizes being offered. Organizers planned to showcase the latest achievements in flight. "It is the purpose and desire of the Aero Club of Ohio that there may be a thorough exposition of the development of aerial craft," the article said.

There were plenty of amazing feats and near disasters at the show. Indeed, the aviators themselves said it was "the best first day efforts of any meet in the country" in 1911. Bookins opened the meet by setting a world spiral record, thrilling the audience by straightening out only five feet from the ground, flying at a speed of 50 miles per hour. *The New Castle News* described the amazing achievement on September 27, 1911: "From a height of 1000 feet, Walter Bookins, dean of the American flying corps, came down in a spiral in his Wright aeroplane with his motor and fans stopped and landed almost exactly on a spot marked out in the center of the aviation field." Ely plunged from 100 feet when an air current caught his plane. *The Van Wert Daily Bulletin* in Van Wert, Ohio, said he "sustained a bad cut over his right eye, several bumps on the back of his head and smashed the front end of his machine. One of his planes hit Atwood's machine as the latter was about to arise. The accident happened just as Ely attempted to turn at the end of the field, half a minute after he had arisen for the first time at the meet." Atwood crashed into a Santos-Dumont Demoiselle plane while taking off.

Atwood and Bookins spent most of the meet showing off and trying to outdo each other. Highlights included Atwood dropping bags of flour to simulate bombs, demonstrating how planes might be useful in wartime. Bookins pushed the envelope by "racing around the ends of the field as a race horse around a mile track, flying at times no more than two feet

off the ground," according to McCrea. Henry Holsinger of Cleveland did parachute drops from his balloon at a height of 2,000 feet. Spectators could take rides in an aeroplane for the staggering sum of $100 per person. Mr. & Mrs. H. H. Timken, W. R. Timken, Mrs. Ralph Rex, E. J. Heminger, Fred Seiberling, and 15-year-old Mildred Laiblin all went up for a ride. *Repository* writer Ann Miller went up with photographer Fred T. Martin, who took the very first aerial photographs of Canton.

While no one was seriously injured at the meet, there was a tragic accident on a Wheeling & Lake Erie Railroad excursion train on a return trip from Canton, as reported in the *Evening Telegram* in Elyria, Ohio, on September 28, 1911. "Two box cars laden with brick broke loose from a string of cars on a siding at the Canton Pressed Brick Company and ran down through the switch out onto the main track. The excursion train running around a curve collided with the two brick cars."

The engine was badly smashed, and the baggage car behind the engine was thrown over on its side, tossing a fireman and engineer from their car. The fireman was not injured, but engineer Henry Johnson of Canton was severely bruised. The article went on to say, "Passengers hurried from the coaches before the cars stopped rocking after their sudden stopping." Two people were killed and eight were injured. One body was found on an embankment and was identified as a Minerva man who was riding the "bumpers" of the baggage car. The other dead man was pinned in the wreckage. The dead were thought to be two young men who had climbed between the baggage car and the smoker "after being put off at the Wheeling & Lake Erie depot with two other young men by a railroad detective." Riding between cars was unsafe, and proved deadly in the event of a derailment.

In spite of the railroad tragedy—and a few bumps and bruises on some of the aviators—the air meet was deemed a success. In just a few short years, Canton had emerged on the scene as a major center of aviation activities. Frank S. Lahm's dream of bringing the thrill of flight to Canton had indeed come to pass.

2. Opening Doors for the Wright Brothers
The Lahms, Orville, and Wilbur

Even before introducing his hometown to the thrill of balloon flights, Frank S. Lahm began playing a much larger role in the future of aviation. On December 29, 1905, he attended a meeting of the aviation committee of the Aero Club of France, which had been set up to encourage heavier-than-air flight by French inventors. In his pocket was a 10-page letter from his nephew Henry Weaver of Mansfield. Lahm planned to share the contents of the letter with his fellow aviation enthusiasts.

At their last meeting, there had been great debate about the "new claims" of the Wright brothers, who had reportedly made longer flights in an improved flying machine. Most of his fellow committee members were incredulous that American inventors would outshine the French, who had already made great strides in the field. Lahm had not participated in the debate. Instead, he went about quietly verifying the Wrights' claims by sending his nephew to investigate.

After the regular business of the meeting had been concluded, Lahm read his letter to the assembled committee. Weaver stated he had personally interviewed Orville Wright at his home, and that he had given a "wholly believable account of the flights in question." Weaver also met several "reputable persons" who witnessed test flights in Dayton. He described the machine as told to him by Orville Wright, who supplied details about its weight and horsepower. He continued:

> The farmers living nearby are the only ones who had had the opportunity of watching the experiments and after two years of such experiments, have lost what little interest they had in them. One remarked to his helper cutting corn: "well the boys are at it again," then went on cutting corn, at the same time keeping an eye on the great white form rushing about its course.

Weaver added that neither of the brothers had married, "because, they said, they did not have the means to support a flying machine and a wife too."

Lahm believed that sharing his letter would end the debate. Instead, the arguments grew more intense, lasting well into the night. It seemed his French friends could not accept his "proof." Much to Lahm's dismay—and no doubt embarrassment—the Wrights made no public or private flights for the next two years, while the French continued to make progress.

Meanwhile, Lahm's son had been assigned to the French Cavalry school in Samur for the term beginning October 1906. As we have seen, Frank P. Lahm made several balloon flights before starting class, and it was during this period that he won the famed Gordon Bennett Cup. He received orders to return to America and report for duty at Fort Myer, Virginia, with the newly created aeronautical division of the Signal Corps.

However, typhoid fever prevented him from leaving on time. While recuperating near his father's residence, Wilbur and Orville Wright came to France to negotiate the sale of a French license under their patent. After sending his nephew to meet with them, Lahm had frequently corresponded with the Wrights, so they paid him a visit while they were in town. "One day my father walked into the garden where I was staying outside of Paris, with the two Wright brothers," Frank P. said. "That was my introduction to Orville and Wilbur Wright."

Frank P. was very interested in their flights and asked the Wrights about their opinion of using the flying machine as a military weapon. In the course of conversation, Frank P. was surprised to learn that nothing had come of their efforts to sell one to the U.S. government. This conversation would begin a series of events that would eventually win the Wright brothers a government contract, with the help of Frank P.

Having spent two years quietly defending his countrymen's claims, Frank S. Lahm asked if they had brought a machine with them to France. Wilbur Wright said they did have one in storage at Le Havre, and said, "We are prepared to make demonstration flights in connection with our business here." Lahm must have been relieved that finally, his French colleagues would have to believe the Americans' claims of flight.

Unfortunately, the licensing deal fell through, and the Wrights did not demonstrate their flying machine as planned. Lahm was probably quite chagrined when French aviators continued to make headlines, and still he had no definitive proof of the Wrights' success.

That summer, Wilbur Wright came back to France and was more successful in his business ventures. He made several flights for throngs of French spectators. At last, Lahm was vindicated. Soon afterward, he received his first ride in a heavier-than-air machine, piloted by none other than Wilbur Wright.

There was considerable overlap between the early heavier-than-air machines and balloons. The front page of the *Washington Post* on August 9, 1908 featured two stories illustrating how the two modes of transportation existed side by side for a while, both capturing people's imaginations:

WRIGHT MAKES FLIGHT
American Aeroplane Under Complete Control
Travels Nearly Two Miles
Inventor Makes First Public Test at Lemans, France, in Journey Lasting
One Minute and Forty-six seconds. Machine Soars, Mounts, and Circles.
Attains Height of 60 Feet.

SKY PILOT UP IN OHIO
Cleveland Men Fly Balloon From Canton Despite Weather Conditions

Other newspapers covered both stories simultaneously as well. The day before the *Washington Post* articles were published, the *Racine Daily Journal* reported, "American in Rapid Flight" and "Airship Flight in Ohio." As is often the case, an old chapter does not necessarily close when a new one begins. They often co-exist.

The Wright brothers and their sister Katherine soon became close friends of the Lahm family. Years later, Frank P. Lahm wrote about the letters and cards written to his father, "in which they express their esteem, yes their affection for the one who was a firm believer when the world was still doubting their exploits, a staunch supporter who never failed to uphold them and to combat their detractors." The Wrights visited Lahm often at Turkeyfoot Lake and Canton, where they participated in some of the activities of the Aero Club of Ohio.

After meeting them in France, the younger Lahm also became an outspoken supporter of the Wright brothers, and was partially responsible for their success with the U.S. government. By 1904, the Wright brothers were aware of their invention's potential, but no government official would listen to them about the success of their test flights. The idea of a heavier-than-air flying machine was the stuff of science fiction to most people in the early 20th century. No one could comprehend that someone had finally conquered the challenge of powered flight. Although foreign governments had approached the Wrights about purchasing a plane, they firmly believed their own government should have the first chance to contract with them.

In an interview with Air Force General Laurence S. Kuter when he was 77 years old, Frank P. Lahm discussed the attempts made by the Wrights to get the attention of their government:

> On January 15, 1905, they wrote to their congressman down in Washington, who contacted the War Department, as recorded in a letter from the Board of Ordnance and Fortification, which was charged with new inventions. The Board went on to state that they were not furnishing funds for the development of aircraft, etc. They turned it down, in other words.
>
> October 9, 1905, after they had flown over half an hour, they wrote directly to the Board of Ordnance and Fortification. Again they got a noncommittal reply. . . . There was some reason for that. They [the board] had put up $50,000 for [Samuel] Langley's machine, which had not flown, and they had been roundly censured by the public and the press for wasting money on such a thing as a flying machine.
>
> In the spring of 1907, some members of the Aero Club of America wrote the President, [Theodore] Roosevelt. He passed it down to the Secretary of War, Taft, and that got to the Board of Ordnance and Fortification—so they had to sit up and take notice. However, they replied again, this time stating that they didn't have the money—so again they turned the Wrights down.

After speaking with the Wrights and with his father, Frank P. Lahm became convinced that they were what they claimed to be, and that their flying machine would be of use to the government. "While the Wrights were talking of their plight," said Larry Lahm, "my father said to them, 'It is a shame that an American invention would not be purchased by the U.S. government.' The Wrights asked my father if he could influence the government when he went back to the U.S., which he did." In October 1907, Frank P. Lahm took it upon himself to write a letter to the chief signal officer, Brig. Gen. James Allen. Although Lahm would often understate his role, his letter finally opened a door for the Wright brothers, and Wilbur was asked to appear before the Board of Ordnance and Fortification.

Wilbur Wright made no fantastical claims about what they could do. He made a positive impression on the board, which drew up a list of specifications for an airplane based on what the Wrights said they could produce. They said

their machine could fly 40 miles per hour, carry two people, land and take off without undue delay, and could easily be dismantled and loaded onto an escort wagon for transport. When the specifications were advertised, the government received 41 bids. "The prices varied all the way from $100 to $10 million for an airplane," Frank P. Lahm said, "and one man said he was sure that his airplane could fly at least 500 miles an hour." Three of the bidders were offered contracts, but only the Wrights could meet the specifications. They offered their plane for $25,000.

Three officers, including Frank P. Lahm, advised President Theodore Roosevelt to make the $25,000 available for the Wrights. They signed a contract on February 10, 1908. On August 20, 1908, Orville Wright came to Fort Myer, Virginia, with their plane and did a few test flights. "On September 9, 1908, he flew fifty-eight minutes, I believe it was," said Lahm, "and when he came down he came over to me and asked me if I would like to go up a little. You can guess my answer." They flew for about six minutes. It was Frank P. Lahm's first time in a plane.

A "festive" atmosphere prevailed. Lahm wrote, "Some of the socialites brought beverages and sandwiches in their autos, which they shared with their friends, thus making quite an unusual social event of the official trials." A few days later, the festivities turned tragic. On September 17, Orville went up with Lt. Thomas Selfridge and they had a horrible accident. A crack in the right propeller caused it to break, snapping a rudder guy wire. Selfridge became the first airplane crash fatality, and Orville was seriously injured. No more flights were conducted on that trip.

The next year Orville and Wilbur both came back in July with a rebuilt plane to perform some of the other airplane trials. Everyone was extra careful after the tragedy the year before. Lahm wrote, "Flights were made only in light winds, and while large crowds and high officials were often disappointed, the Wrights were adamant in their decision not to fly unless conditions were just right." Orville took Lahm up for an endurance flight that lasted one hour and twelve minutes, setting a new world record. Next came the speed test, at which they also excelled. By then, government officials decided they had fulfilled the contract, except for teaching two officers how to fly.

Lahm and Lt. Frederic E. Humphreys were chosen to become the first military aviators. No air field existed, so the military searched for a suitable place to begin flight training. The commanding officer at Fort Myer refused to give up his parade ground for further training, since the flight trials had disrupted his mounted drill schedule. Besides, the Wrights were not fond of that field, believing it was too small and enclosed. The government wanted

someplace near Washington, D.C., with a favorable climate for aviation. That meant no high winds and minimal inclement weather, since the pilots were exposed to open air and it was difficult to operate the controls with cold hands and feet. In those early days, aviators wore no helmets or goggles of any kind, because they obscured visibility and restricted movement.

Lahm recommended a site at College Park, Maryland, because it was surrounded by low hills, was not near a large body of water, and had relatively calm winds. Soon the training of the world's first military aviators began. Both students were present when Wilbur reassembled the plane. They helped unpack the crates, put together the pieces, and adjust the engine.

As with balloon ascensions, the best time to begin is in the evening when the winds go down, or early in the morning. Neither Wright brother would fly on Sundays, influenced to observe the Sabbath by their father, who was a minister. Lahm was the first student pilot, because he had had the most experience, though it had just been two flights at the trials. First they learned how to take off. Those first flights were more like "short hops" of 20 or 30 feet. As the students became comfortable with the feeling of being in the air, the flights became longer and longer. Wilbur would fly them up higher if they needed more distance from the ground to practice something. The Wright Flyer landed with a dead motor, which was perhaps the hardest part to master. Sometimes the engine stopped in midair, so Wilbur would demonstrate powerless landings from a high altitude.

The students also learned through "imaginary" flights, where they would sit in the plane with Wilbur as he threw out various scenarios. The students would then describe how they would handle the situation. According to Cathy Allen at the College Park Aviation Museum, Wilbur would say something like, "We are going along now at a fast clip and want to turn to the left." Then one of the students would take control of the levers and simulate maneuvering the plane up or down.

There were three reporters covering the flight lessons, which often made headlines in papers large and small. One widely reported story occurred on October 19, 1909. Wilbur was up with Lahm, when suddenly the engine sputtered and stopped. Wilbur remained calm and skillfully guided the plane to the ground. He spent hours trying to figure out what had caused the engine to quit, when suddenly, in front of a considerable crowd, he jumped up into the plane and opened the gas tank. "The joke is on me boys," he said. "The bird won't fly without gasoline."

Thankfully no serious accidents occurred during the lessons, but a few other incidents added some undue excitement to the scene. On October

21, Lahm flew his longest flight yet with Wilbur, spending 33 minutes in the air. While landing, two spectators crossed in front of the plane and were almost struck. Wilbur reportedly shouted warnings, and then grabbed the controls to swerve the plane to one side and avoid the people. Crowds continued to be a problem throughout the flight lessons.

The entire training session took about two weeks. "In October 1909, Wilbur Wright took on Lt. Humphreys and myself," wrote Lahm, "and after some three hours or more we were soloed and were told we were pilots." He was exaggerating when he said that, but only slightly. The Wrights themselves had not had all that many hours of flight time. The new pilots would need to develop an instinct for balance, and a "feeling" for flight that could only be learned through experience. Wilbur passed on what he knew, and then let the boys fly on their own. And he proved to be an excellent instructor. Lahm recalled, "no question . . . however unimportant it might seem, failed to have careful consideration and a well thought out answer; and you may be sure we asked many questions." Wilbur Wright's last flight in public was with Frank P. Lahm, and it was one of the last flights he ever made before his untimely death from typhoid fever in 1912.

The following list is a complete record of Frank P. Lahm's flights at College Park, Maryland in 1909, from *How Our Army Grew Wings*, by Charles Chandler and Frank P. Lahm:

DATE	WITH WHOM	LENGTH OF FLIGHT
Oct 8	Wilbur Wright	5 minutes, 8 seconds
Oct 15	Wilbur Wright	4 minutes, 48 seconds
Oct 15	Wilbur Wright	14 ½ minutes
Oct 16	Wilbur Wright	13 minutes, 44 seconds
Oct 18	Wilbur Wright	18 minutes, 37 seconds
Oct 18	Wilbur Wright	11 minutes, 34 seconds
Oct 18	Wilbur Wright	9 minutes, 19 seconds
Oct 19	Wilbur Wright	4 minutes, 10 seconds
Oct 19	Wilbur Wright	18 minutes, 6 seconds
Oct 20	Wilbur Wright	6 minutes, 28 seconds
Oct 21	Wilbur Wright	33 minutes
Oct 23	Wilbur Wright	18 minutes
Oct 23	Wilbur Wright	11 minutes
Oct 25	Wilbur Wright	18 minutes
Oct 26	Lahm solo flight	13 minutes

Oct 26	Lahm solo flight	5 minutes
Oct 26	Lahm solo flight	40 minutes
Oct 27	Humphreys	36 minutes
Oct 29	Humphreys	1 minute
Oct 30	Humphreys	14 minutes
Nov 1	Lahm solo flight	16 minutes
Nov 1	Lahm solo flight	58 minutes, 30 seconds
Nov 2	Wilbur Wright	2 minutes
Nov 3	Sweet	9 minutes
Nov 5	Humphreys	9 minutes

After their solo flights, Lahm and Humphreys were pronounced pilots on October 26, 1909, and together they made up the first military aviation branch in the world. Lahm's first passenger was Lt. George G. Sweet, who became the first naval officer to fly in an airplane. Lahm and Humphreys continued to practice flying, both alone and together. On November 5, with Lahm at the controls, they made a low turn and the wing just clipped the ground. The plane began to do cartwheels, which caused some damage. Fortunately neither pilot was injured. But since Wilbur Wright had already left College Park, repairs could not be made immediately. The Army had to order cloth for the wing from the Wrights' factory in Dayton. A few weeks later, Lahm was reassigned to a cavalry unit in Kansas, thus ending the first flight lessons.

In 1907 Lahm had operated the first army airship, so his newest accomplishment made him the only military officer licensed to fly a balloon, a dirigible, and an airplane. That first plane—made of "spruce, piano wire, and faith"—ordered by the government is now part of the collection at the Smithsonian's National Air & Space Museum in Washington, D.C. Frank P. Lahm remained active in aviation for his entire military career. In 1911, he was transferred to the Philippines where he opened a flight school at Fort William McKinley near Manila. There he trained several pilots using a Wright Type B plane. In May 1917, he became the commanding officer of the Army Balloon School at Fort Omaha in Nebraska. During World War I, he organized the American lighter-than-air service in France, returning to his first experience with flight. Later in the war he commanded the air arm of the 2nd Army, which won him a distinguished service medal. After the war, he helped to create a large training center at Duncan Field near San Antonio, which became the Gulf Coast Air Corps Training Center with headquarters at Randolph Field. He was in charge of Air Corps pilot training

from 1926 to 1930. In July 1930 he was appointed assistant to the chief of the Air Corps, with the rank of brigadier general. He retired on November 30, 1941, days before Pearl Harbor, and was honored by spectacular aerial and ground demonstrations attended by 20,000 people. In 1943, he co-authored *How Our Army Grew Wings*, which has become a standard text in military aviation history.

Throughout his career, Lahm never forgot who had given him his early interest in aviation. He revered his father, and was a proud son. In his lifetime, Frank S. Lahm made over 30 balloon ascensions, the last one when he was 85 years old. He was the oldest pilot in the French Aero Club and had known many prominent figures in the history of aviation. Lahm had been active in the reception for Charles Lindbergh when he first crossed the Atlantic. He was instrumental in securing the services of Henri Julliot, French aeronautical engineer, for the Goodrich Rubber Company. Julliot went on to become the technical authority for a series of airships the company constructed. Walter Wellman, who made two unsuccessful attempts to reach the North Pole and one failed transatlantic crossing in a dirigible, was "given his baptism of the air in a balloon ascension piloted by Mr. Lahm from Paris in January 1906," according to his son. Lahm taught many people how to fly a balloon, and assisted them with obtaining their pilot's licenses. The regulations required that each potential pilot make ten ascensions, including one at night and one alone.

At the outbreak of World War I, the elder Lahm was commissioned as a technical expert for the Balloon Service. He declined twice, saying a younger man should be assigned to that post. Eventually he acquiesced, with the stipulation that he serve as a civilian, not a member of the military. His duties included visiting balloon factories working for the government, reporting on parachutes, and investigating the practicality of building and operating propaganda balloons to float over enemy territory. As part of his position, he compiled a glossary of balloon terms in French and English.

Frank S. Lahm won several awards in ballooning, and was highly respected in aviation circles. In 1905 he became the first winner of the Bigault de Graurut contest for landing closest to a previously designated spot in France. The same year he took home the Figaro Cup in his balloon the *Katherine Hamilton*. He started from Paris and flew through the night in the rain, landing at Loo, Belgium, the next day, covering a distance of 150 miles in 17 and a half hours. He commented in his flight log, "Prize 800 francs which I won. It rained constantly . . . we were soaked through. Never so wet in my life. Our clothes dried on us."

His travels spanned the globe, and he had the opportunity to view the activities of aero clubs of many countries. He carried a collection of lantern slides with him on his trips, giving many illustrated talks about aviation. Lahm was present with Orville and Wilbur Wright when the Aero Club of Detroit was launched in 1909 and he presented one of his balloon talks. The Wrights themselves declined to speak that evening, as they did all their lives.

In 1924, he was honored as a Knight of the Legion of Honor for "services rendered to French aviation." *The Repository* covered the story, reprinting an article from the Paris edition of the *New York Herald*, and noting that the list of recipients included only four Americans:

> A new Knight is Mr. Frank S. Lahm, of Canton, O., who is now probably the dean of the American colony in Paris, with nearly forty years of continual residence. . . . Mr. Lahm is prominent in international aeronautic circles and is an American delegate and vice-president of the International Aeronautic Federation. . . . Mr. Lahm was largely responsible for the coming to France of Wilbur Wright to conduct his successful experiments near Le Mans in 1908. When only unbelievable reports came out of Dayton of the success of a flying machine built by the Wright brothers, Mr. Lahm had an inquiry made by Ohio friends and became convinced of the value of the Wright machine. As the only American in Europe then conversant with the newest step of aeronautic development, he was called upon to furnish the Old World with news of the progress made.

That same year, Frank S. Lahm was made president of the Canton Chapter of the National Aeronautic Association, a successor of the Aero Club of Ohio he had founded years before. A dinner was held in his honor at the Canton Club on November 14, 1924. A special balloon ascension was organized, the first since the Aero Club's last flight in 1910.

In the spring of 1931, Lahm invited a small group of friends to dine with him in celebration of his 85th birthday. When a guest asked him how he was able to live so long, he said, "I think a proper diet is one of the reasons. Another important thing is that I have learned not to cheat myself of sleep." Indeed, it is remarkable that a man who had been so sick he could not attend his young wife's funeral was able to live such a long and fulfilling life, and leave such an indelible mark on the history of aviation. Canton's history, as well, was greatly enriched by his activities.

Knowing the end was near, the younger Lahm brought his father back to the United States for the last time in 1931. "He underwent a serious operation in Paris in the summer of 1931 and as soon as he was able to travel, I brought him here for a final visit to his beloved Turkeyfoot Lake," wrote Frank P. in a letter to the Stark County Historical Society in 1960.

Frank S. Lahm died on December 29, 1931, in Paris. According to a report of the U.S. Foreign Service, the cause of death was cancer. His remains were sent to the United States for interment at Mansfield, Ohio, where he was laid to rest alongside his wife and their infant daughter.

Condolences poured in from every corner of the Earth. The Paris chapter of the National Aeronautic Association sent the following resolution:

> Whereas his enthusiasm for Aeronautics, both in France and America, during his long service, firstly, as a member of the Aero-Club of France and Vice-President, for more than twenty-five years, of the International Aeronautic Federation, then his unselfish aid and encouragement to the Wright brothers, which ultimately brought about their recognition; and finally his most distinguished services to the Government at Washington during the late war, all bear witness to his inestimable contribution to this work.

Although he had never worn the uniform, Lahm received a military funeral, indicating the gratefulness of his native government. Orville Wright served as an honorary pallbearer. "A blimp from Akron dropped flowers from the air," Frank P. wrote, "and three airplanes from the 112th National Guard Observation Squadron from Cleveland circled over head. As he was lowered to his last resting place a firing squad from Battery D of Mansfield fired three volleys and the bugler sounded 'Taps' which marks the close of the day."

Rev. Dr. A. M. Hughes of the First Presbyterian Church in Mansfield read the following remarks at his service:

> Here is the life of Mr. Frank Lahm. Eighty and five years— a well rounded life. A life full of friendships . . . A man of "inner integrity" that worked itself out into a man of sterling character. Appreciative of Art. Familiar with the great paintings of the world, and a lover of beauty in every form. Appreciative of Home, children and friends. . . . Interested in Aeronautics,

being one among the first to have faith in its possibilities and sharing that faith with struggling genius who were endeavoring to make their dreams come true. . . . Interested in inter-national peace and good will. Though for many years, living in France, he always maintained his "home" in America. But because of his sterling worth in terms of national friendship the French Government gave to him a decoration of honor. Men who have lived and worked for a better understanding between nations have not lived in vain. Future generations will rise up and call their names "blessed."

Yes, it is true gone from our sight, gone beyond our horizon, but into the sight of others, into horizons anew, into another harbor, always in the sight of God. But if we could change the figure for a moment and think of a little boat going down the river. We might watch it turn the bend in the river and to us it would be out of sight, but to one in an aeroplane, seeing from above, all the turns would be as a straight course. So as our little boats go down the stream of life, various bends of the river may take us out of sight one from another, but the God of Love who sees from above, we are in His sight forever.

Frank P. Lahm carried on his father's legacy by making lasting contributions to aviation. He died July 7, 1963 at Good Samaritan Hospital in Sandusky, Ohio. He was widely respected in aviation circles and was well known for his refined character, a trait he inherited from his father. In July 1911, Alan R. Howley, winner of the 1910 Gordon Bennett Cup balloon race, told the *New York Herald*, "Lt. Lahm is a prince among gentleman and a gentleman among aeronauts." In the same article, balloonist Leo Stevens said, "He is always cool and collected, doesn't know what fear is and is free of that bravado that leads to foolish risks." The reporter gave the following description of the younger Lahm:

Imagine a man of spare but athletic figure, under the six foot mark, modest in demeanor and retiring in disposition, seldom speaking, but always an attentive listener, and you have a good idea of the external Lieutenant Lahm. Then endow this man with the courage that defines the unknown and the daring that attempts the untried, both tempered by a knowledge and a prudence that bar the reckless element, and you will know Lieutenant Lahm for what he is.

In 1995, Frank P. Lahm's son Larry wrote an essay about his personal recollections regarding his father. He was the epitome of a gentleman, much like his grandfather, Frank S., with many varied interests and a keen appreciation for culture. He created a poignant and personal view of the father he adored:

> He was five feet nine inches tall and was always very slender so that he appeared taller than he was actually . . . As a boy I liked to watch him shave in the mornings, partly because he splashed so much water about. At West Point he had been a gymnast and the muscles of his arms and back stood out like ropes.
>
> He was soft spoken and agreeable, yet, there was always a certain reserve. He was modest, honest and true. He spoke well of others. As a boy he had gone to church twice on Sundays, once in the morning and once in the evening. He visited the sick and the aged.
>
> He loved games and we played checkers, Parcheesi, backgammon, and mahjong. He also played bridge. He was an avid hunter and fisherman. I remember stuffed trophies like a moose head, a mountain goat, and a deer head hanging in the dining room and living room. I accompanied him on a wonderful fishing trip up into the north of Canada as far as the southern tip of Hudson Bay. The fish were there in large numbers.
>
> He was first a cavalryman before he became a flyer and he enjoyed riding and polo. In San Antonio, Texas he had three polo ponies. I was never allowed to ride them. Presumably because I would spoil them. He did, however, teach me to ride other horses and to swim, to golf and to play baseball.
>
> He guided me well but not too closely for he was a very busy man and bore heavy responsibilities. He provided me with a superior primary education, much of it in private schools— all of this carefully designed to get me into and through West Point. I graduated from the Academy in 1942, 41 years after his class of 1901.
>
> He enjoyed music and we sang on the long automobile trips when he changed stations from one Army post to another, my father and mother in the front seat and my sister, Barbara, and I in the back seat. He enjoyed living in big cities for the cultural benefits they offered.

His posture was firmly erect and he possessed a cold courage which was remarkable. Beneath the calm exterior lay the competitiveness and combativeness fostered by the severe training at West Point. That courage had carried him through his early free ballooning, through World War I in France and through the flights in the unstable Wright airplanes of 1908.

In summary, he was for me a figure greater than life, much older, much wiser, so distinguished and a commanding general.

It is a source of great pride to me that I am his son.

Frank P. Lahm and his father Frank S. Lahm have often been described in similar terms. Both understood their contributions to aviation, but neither man sought fame from it. They were solely interested in promoting aviation for sport, science, and human advancement. Before his death, the younger Lahm made several significant donations of his father's aviation related materials to the Stark County Historical Society, preserving his life for future generations.

While the Lahms were not looking for fame in connection with their aviation activities, another man with ties to Canton was doing all he could to achieve notoriety. Walter Wellman, whose first balloon ascension had been with Frank S. Lahm in France, desperately wanted to be famous for his daring expeditions in a dirigible.

3. A SPLENDID DREAM
Wellman's Airship America

Walter Wellman is not likely a household name, but his contribution to aviation is significant nonetheless. Better known as a newspaper editor, who spent time working at *The Repository* while living in Canton, Wellman had an adventurous side that led him on five expeditions to the North Pole. He was also the first person to attempt a transatlantic voyage in a dirigible. Although all of his attempts were dismal failures, his contemporaries celebrated his courage to even attempt such perilous journeys.

Wellman was born in Mentor, Ohio, on November 3, 1858, the son of Alonzo and Minerva Graves Wellman. He claimed later in life that his most treasured possession as a child was his dictionary. At the age of 14, while he was still in school, he founded a weekly newspaper at Sutton, Nebraska, in 1872. When *The Repository* switched from a weekly to a daily in February 1878, the newspaper needed extra staff to take on the additional work. Wellman found a job at *The Repository* as a printer, reporter, and editor. On Christmas Eve 1879, Wellman married a local woman named Laura McCann in her parents' home on the corner of High and 5th Street SW (which was then 10th Street). Rev. Hiram Miller, pastor of the First Methodist Church, performed the ceremony. The Wellmans had five daughters: Ruth, Rose, Rae, Rita, and Rebecca. After Laura's death, Wellman later married Belgljat Bergerson of Norway, and had two sons, Walter Jr. and Francis, and a daughter Elsa.

Wellman spent a year covering Canton news in the pages of *The Repository*, but he was not content living in such a small community. He and his brother Frank went to Cincinnati and founded *The Penny Paper* on January 3, 1881. The brothers were struggling financially when Edward Scripps bought their paper later that year and changed its name to the *Cincinnati Post*. The Wellman brothers made two more attempts to start their own newspaper. They started the *Cincinnati Sunday News* in 1881, but abandoned it after only a few months. In March 1882, they returned to northeast Ohio and started the *Akron Daily News* to compete with the *Akron Beacon-Journal*. Again, the brothers gave up.

Wellman then landed a position as a correspondent for the *Chicago Herald*. His editors were impressed with his work and gave him increasingly important assignments. In 1884 he went to Washington, D.C. to head up the *Herald's* news bureau there, covering national politics. Later he also served as president of the Washington Press Club. In 1904, an article in the *Daily Review* in Decator, Illinois, announced that Wellman would be giving a lecture at James Millikin University, saying "such a well known man as Walter Wellman will certainly be a big drawing card." His lecture was called "Behind the Scenes in Washington." Describing some of Wellman's work, the newspaper said, "His reports on the great anthracite coal strike attracted attention throughout the country. In efforts to settle the strike he was a confidential intermediary between President Mitchell and J. Pierpont Morgan, and afterwards was asked by President Roosevelt to continue in the same relation for him."

Somewhat of an eccentric, Wellman first entered the public eye when he claimed to have identified the exact spot where Christopher Columbus landed at San Salvador. He made his first attempt to reach the North Pole by sled in 1894. He tried again in 1898 and 1899, each time failing to reach his destination. On the 1899 trip, Wellman seriously injured his right leg, which became gangrenous. For four months he could not walk at all. It would be two years before he fully regained his health, and he was left with a permanent limp from his injury.

After three tries, Wellman was looking for an easier way to reach the North Pole. He decided to ditch the sled and try again by air. He had made his first ascension with Frank S. Lahm in the *Katherine Hamilton* in January 1906 and decided the easiest way to reach the North Pole would be to float above the treacherous ice and snow. Although the Wright brothers had already made several test flights, many still believed the future of aviation was not in heavier-than-air flight. Advocates of ballooning thought the laws of physics and aerodynamics made even the idea of mechanical flight entirely impractical. Wellman's opinion was unwavering, as he wrote in *The Aerial Age*:

> If the mechanical flight machine were as simple as the bicycle, if it were as easily mastered, if use of it were no more dangerous, it might have a future as a useful vehicle, small as it is, and costly as it is. But it is not simple; it is not easy; it is hazardous. And in its present form there is little reason to hope for its adoption even as a limited social vehicle—for tours in the country, for excursions, for going to and from town, for messengers, doctors,

errands, visits. In other words, it does not bid fair in any sort of
degree to take the place of the bicycle.

Indeed, if Wellman planned to take to the skies, he would not be doing it
in an airplane.

Wellman chose to use a dirigible for his next two arctic explorations, the
first in 1907 and the second in 1909. The first trip ended very quickly when
he ran into a snow and ice storm that left his airship in ruins. Thankfully
none of the crew was hurt. On his second attempt, he had traveled 33
miles when a leather strap holding 1,000 pounds of provisions broke free.
According to the *Lincoln Evening News*, "By skillful maneuvering, Wellman
succeeded in landing without injury of the crew, though the *America* was
badly damaged."

While planning yet another trip, news reached Wellman that Robert
Peary and Frederick Cook both claimed to have reached the North Pole.
"I turned next to a project which had long been in my mind," wrote
Wellman, as he set his sights on making the first transatlantic voyage. Plans
began immediately. The trip was backed by the *New York Times*, *Chicago
Record-Herald*, and the *London Daily Telegraph*, which together provided
$40,000 of the $50,000 needed to complete the mission (Wellman himself
agreed to make up the difference). In the late 19th century, newspapers
had discovered that financially supporting explorations to exotic locations
was quite lucrative. The sponsoring publication would have exclusive rights
to the story, while rivals had to settle for second-hand accounts published
after the fact. Circulation often skyrocketed for the newspaper that made a
financial commitment to a fantastic adventure.

Wellman did not want to be upstaged again, so he had to assemble a
team and build an airship fast. He feared the French or Germans might
make a transatlantic crossing first, since their recent experiments had been
so successful. He decided to pursue a west-to-east course to take advantage
of the prevailing winds. He chose Atlantic City, New Jersey, as a departure
point, even though there were places further east in the United States,
because that city had a well-funded aero club that would support his efforts.
The wealthy members of the club built him a $12,000 wooden hangar to
assemble his airship.

The *New York Times* described the dirigible *America*, saying, "The ship
was the nearest thing in shape to a cigar, which aeronautics has produced. .
. . The contents were well clothed. The balloon itself was composed of three
thicknesses of cotton and silk, gummed together with three layers of rubber,

weighing 4850 pounds." Three motors allowed it to travel at 20 miles per hour. In total, the airship held enough gasoline to keep the motors running for 50 days at low speed to make the 3,000-mile trek to Europe. It was 228 feet long, 52 feet at its greatest diameter, and could hold 345,900 cubic feet of hydrogen gas, which is 12 times lighter than air. Hydrogen gas is odorless, so Wellman had his scented with peppermint oil, so he and his crew could detect any leaks in the massive bag.

Piloting an airship was no easy task. Several outside factors could alter the course of the *America*. "An airship is peculiarly sensitive to any change in meteorological conditions," Wellman wrote. "It is affected by winds, sunshine, clouds, heat, cold, moisture, atmospheric pressure. All these mutations must be taken into account by the aeronautic engineer." Knowledge of physics, mechanics, chemistry, metallurgy, motors, meteorology, nautical astronomy, seamanship, compasses, and fuels would all prove useful as well.

Perhaps the strangest component of the massive beast was the "equilibrator," a massive experimental stabilizing unit attached to the craft, whose purpose was to regulate the upward and downward course of the ship. Invented by Melvin Vaniman, chief engineer of the *America*, it took the place of a drag rope used on balloons. It was feared that as the dirigible moved across the water, strong sunshine would force it to spring uncontrollably toward the clouds. The equilibrator floated along the water attached to the airship with cables, providing a kind of "anchor" system to prevent it from floating too high. The equilibrator also provided a place for the crew to unload ballast without losing it. Without it, ballast would have to be thrown into the sea and lost. In a sense, the equilibrator served as a temporary storage unit for ballast that was not required at night when falling temperatures caused the airship to descend, but was essential the next day as the hot rays of the sun heated the gas and forced the balloon higher. The same ballast could be used over and over again, every day of a prolonged voyage. The equilibrator also served as another kind of storage unit, containing 2,000 gallons of gasoline. Three steel cables were attached to 30 small steel drums, each containing about 75 pounds of gasoline. "As the gasoline is required," reported the *Mansfield News*, "the steel cable will be pulled up into the car of the balloon and a tank emptied."

According to Edward Mabley, author of *The Motor Balloon "America,"* the equilibrator served in two other capacities. "By observing its wake, visible under ideal conditions for a mile astern, it could be determined whether the airship was moving head-on her course. . . . Navigation in 1910 was not a matter of following a radio beam, but of close observation of stars, watch,

compass and such instruments, and of dead reckoning." The equilibrator also "served as the surface connector, or ground, for the wireless installed by the Marconi Wireless Telegraph Company." The contraption would prove to be a very bad idea indeed as the voyage unfolded.

The cabin was equipped with storage batteries that provided power for electric lights and the telegraph system. The wireless was capable of sending messages 75 miles. They planned to stay within established shipping routes between New York and the English Channel, and they hoped to keep in touch with passing ships that could relay messages to America and Europe for them. The lifeboat was stocked with enough food to feed six men for a month, including bread, beans, bacon, coffee, Horlick's malted milk, boiled hams, eggs, and tinned meats. The lifeboat also served as an extension of the cabin. During the trip, the men often climbed down into it to rest, smoke, and cook. A small gas stove was used to make meals for the crew, which represented the finest engineering minds of the time.

Wellman chose his crew carefully from among the many men who volunteered from all over the world. Chief Engineer Vaniman was a famous balloonist who would lose his life the following year when the gasbag of another dirigible exploded hundreds of feet above the ground. Despite his "mechanical aptitude," he had no formal engineering training. He had earned a living as a guitarist and music teacher, and later worked as an actor, opera singer, and photographer. He made his first balloon ascension over Paris and Rome to take panoramic shots of those cities. He had also experimented with a plane of his own design near Paris, which was sponsored by none other than Frank S. Lahm. In fact, it was Lahm who introduced Vaniman to Wellman before his polar expeditions. Vaniman was a hard worker, and was completely committed to the project, which must have impressed Wellman.

Jack Irwin, a daredevil Australian youth, was hired as the wireless operator who would be responsible for ship communications back to telegraph offices anxious for updates. Knowing Wellman needed to fill other spots on the crew, Irwin contacted his friend Murray Simon, who had become bored with his New York–Southampton route with the White Star Line's *Oceanic*. Wellman hired Simon as the pilot and navigator. Mrs. Vaniman's brother Louis Loud and Frederick Aubert, who would later marry Rebecca Wellman, served as engineers.

The men Wellman chose were people he knew personally and trusted. Vaniman had served on two previous airship voyages, and Loud had served on one. He had known Aubert for years. Irwin and Simon both had extensive

experience that duly impressed Wellman. "My first thought was one of pride in the gallant men of my crew," he said.

For many days, the *America* hung over Atlantic City, tethered safely in its hangar. For a small admission fee, the public was permitted to view the airship. Edward Mabley, who was only a young boy, was among the spectators. "I remember being taken into the vast and gloomy wooden shed," he wrote, "watching the crew tinker with the motors."

In mid-September, Wellman spoke to the Clover Club in Philadelphia and outlined the lofty goals of his mission. He believed that the "aerialists" had the power to destroy armies, navies, cities, and people. According to Mabley, Wellman expected the flight of the *America* to "advance the cause of peace by demonstrating what could happen in another war." Wellman's speech continued:

> We believe that the airship will do more than any other single agency to bring about universal peace. War is barbaric and should be obsolete. The way to make war impossible is to make it so destructive that all the world will at once see that it is suicide and crime to go to war. We are not hoping to make money, but to achieve something for progress, and for the cause of universal peace. Even in their present experimental stage motor balloons and mechanical flight machines are doing much for peace. Mankind has always had and always will have a love of adventure. In the past this aspiration has found vent in exploration and in war, chiefly the latter. Now it is turning toward the art of aerial navigation. The inventors and pioneers who love to build and plan and try, even at the risk of their lives, are ignoring war and throwing their energies and enthusiasm into the conquest of the air. We are strong in the belief that in the end, and that is not far distant, aerial navigation . . . will be removed from modern heritage, that accursed heritage of . . . killing and destroying on a large scale in the name of patriotism. If my friend Andrew Carnegie, who has already done so much good in the world, wants to bring about universal peace, let him endow with a million or two a plant for aerial development.

His desire for peace not withstanding, fame probably topped Wellman's personal list of goals.

Wellman had sensationalized his trip for weeks, but the lack of activity wore thin on the crowds assembled to see the historic liftoff. People began to lose patience, wondering if they would ever indeed launch the airship, waiting around for something to happen. Many lost interest in the entire affair. Wellman later admitted that the preparations took far longer than expected. "It is not surprising that many spectators became impatient as the weeks dragged on," he wrote. "But the work was complex and difficult, and required patience." Mabley documents one poet's work, which poked fun at Wellman's lengthening series of delays:

"I will not fly," said Wellman,
"Because it looks like rain,
I'll wait until tomorrow
Before I try again."

"I will not fly," said Wellman,
"Because the wind's too strong,
If all is fair tomorrow
I'll rise and sail along."

"I will not fly," said Wellman,
"The day is much too calm,
I'll wait until tomorrow
With patience as my balm."

"I will not fly," said Wellman,
"I feel in need of sleep;
I'll wait until tomorrow,
The air will always keep."

While the *New York Times*, as a sponsor of the venture, ran an endless series of daily updates on the progress of the *America's* voyage, competitors began to insinuate that Wellman was stalling, or worse yet would not fly at all. Wellman categorically denied these claims. "Eagerness to be off instead of hesitation to go was the predominant note from first to last," he wrote. "All the tales told in the press to the contrary were fantastic fakes created wholly out of the imagination without the slightest basis or foundation in fact or incident or word. . . . Every one of us worked with all possible energy to hasten the operation, and it was rather unkind, to say the least, of the

'fake and snake' part of the press to represent us as seeking delay when we were breaking our hearts because things did not go faster." According to Mabley, Wellman did show uncharacteristic worry on at least one occasion, saying, "The combination of a ton of flammable hydrogen, nearly three tons of gasoline, sparking motors, electric light, and wireless, is not one to inspire perfect confidence."

Finally, on October 15, 1910, conditions were favorable and the crew decided to begin their journey. But only a sparse group gathered around the hangar to witness it. According to Mabley:

> Mayor Franklin P. Stoy of Atlantic City decreed that the resort's fire bells be rung before the motor balloon *America* went aloft, "so that all may have a chance to enjoy a view of the ship before she departs for foreign shores." And it was this ambiguous clangor that wakened the town [on] Saturday, October 15, 1910, and sent thousands of hastily clad residents and visitors rushing down the Boardwalk.

Wellman would have his grand liftoff and fond farewell.

On the morning of the launch, it was quite foggy. One can imagine the mood of the crowd as this leviathan moved slowly toward the swirling ocean, casting an enormous shadow, larger than anyone had ever seen before, cutting through the mist. Heads flung back, faces toward the sky, mouths agape as it passed. "The airship *America* was a strange, a marvelous craft," Wellman wrote. "To people who saw her for the first time she seemed mysterious, inexplicable, a nondescript, indeed, unlike anything else that was ever known for sailing upon the seas or running upon the land." Soon the crew appeared, dressed in "khaki aviation costumes." They were already weary from weeks of extensive preparations, but they were driven by their excitement for the adventure ahead.

In the previous weeks, as the crew had prepared for their voyage, a small gray kitten had made itself at home in the hangar. That morning, the cat found itself on the first transatlantic voyage, bound for Europe. Several accounts have been published about why it was aboard. Some sources say Mrs. Vaniman placed it on board with the crew, in the last moments before the airship took off. Others claim the cat belonged to Simon, the pilot, and he brought it aboard himself. When Vaniman discovered it, as that version of the story goes, he tried to lower it in a bag to a small boat in the water below. The water was too choppy, and the transfer could not be made.

Regardless of how the cat came aboard, it was decided that "Kiddo" would be the mascot of the trip.

It took many men to keep the airship from floating away before the crew boarded. Nearly 100 policemen and firemen, who had volunteered their assistance, held on to the ropes. With everyone in place, "the army of strong men below released their hold on the ropes," said a *Repository* writer in 1919. "In the arms of a crisp zephyr the ship of the sky rose fifty feet in the air and floated off toward Europe. Even as the giant ship was launched, no one was sure what was going to happen. Wellman shouted to the crowd, 'We are going for a trial, and if the going is good, we are going up and over the ocean.' "

The massive shadow darkened the harbor. "Rising majestically, the *America* disappeared in the fog almost immediately," said the *Lincoln Evening News*. "Only a tiny motorboat buffeted the breakers and followed in the uncanny shadow cast by this new thing," another newspaper reported.

As they set out, no member of the crew knew if they would make it to the shores of Europe or not. Wellman later wrote, in his characteristic grandiosity:

> Whether this frail combination of art, artifice, and science was to prove a true and serviceable ship of the air, or a grim Frankenstein, we did not know. That is precisely what we were trying to find out. We were trying to achieve with steel, power, engineering and man's mechanical cunning such mastery of space and distance through an aerial ocean never yet traversed as would constitute the realization of a splendid dream. That is what made it worth while. It is always worth while to strive, to venture, to work, to dare—and leave the rest of the gods—in an effort to realize man's dreams of conquest of the elements; to do something—be it much or little—for progress, to widen the frontiers of knowledge and achievement.

As they floated out over the sea, the crew could see that the equilibrator was only one-tenth out of the water, rather than one-half as they had calculated it should be. "At this moment I confess I had my first forebodings of trouble," Wellman later wrote. "But there was not even a thought of turning back." He decided then that this would not be a trial trip. They were over one month past the original launch date, and Wellman worried that if they did not launch then they would have to wait until the spring. They

had known all along as they made preparations for the trip that they were battling a serious weight issue. They decided nothing could be done about it and sailed in the direction of Europe.

Step by step accounts of Wellman's voyage appeared in newspapers across the country, which published a series of "bulletins" to keep readers informed. No one had ever attempted to cross the ocean by air, and the story captured everyone's attention. The newspaper business also had the rare opportunity to salute one of its own. *The Repository* heralded his bravery, saying he "showed the greatest Yank daring in his first attempt, the first ever made, to cross the Atlantic in a dirigible balloon, starting from Atlantic City."

The first message ever received from an aircraft over the high seas reached Atlantic City from the *America* that day. At 1:40 p.m. Wellman reported, "Headed northeast. All well on board. Machinery working well. Good-bye." Mabley recalled the anticipation of the people on shore as they waited for more messages. "I remember the excitement in the hotel the day the messages from the airship were reported," he wrote. "People ashore were nearly as moved and thrilled by Signor Marconi's miracle as were the intrepid band of men out over the ocean." Several congratulatory messages were sent, but no more messages were received from the *America*. The airship's telegraph system was intermittent at best. It was later learned that Irwin, the telegraph operator, had to keep a close watch on sparks from the telegraph equipment, fearing the gasbag could be set on fire. "I think I know how a man committing suicide must feel just before he pulls the trigger," he said.

That afternoon, telegraph operators on shore attempted to reach Wellman to warn him of a tropical storm moving up the coast from Cuba. They wanted to advise him to run the *America* far enough north to escape the worst of the storm, but they received no response from him. Thankfully, the storm blew itself out and did not pose a threat to the expedition.

There were plenty of other problems aboard the airship. While the engines had been tested on the ground before the voyage began, they were not performing well. They needed to be tuned, and the crew had to stop them several times to clean sand from the bearings, which had been carried from the beaches of Atlantic City on the wind while the dirigible was still docked. "Engineer Vaniman and his two assistants Loud and Aubert, worked like Trojans," Wellman wrote. "They did the best they could, but that unfortunately was not good enough; motors are proverbially coy and uncertain." Later in the voyage, one of the engines had to be stopped completely after its propellers began to wobble perilously. The next day,

the crew dismantled it and threw pieces overboard to reduce the weight of the craft.

Other concerns plagued the airship as well. Almost immediately the crew realized the ship was dreadfully overloaded, but they hoped the continuous consumption of gasoline would lighten the load as they traveled. With the engines down most of the time, they did not use a fraction of the fuel they had expected to use on the first day, which kept the weight of the ship high. They were only 80 miles offshore when they should have been 200 miles or more. The crew was forced to throw overboard gasoline that should have been burned by the engines.

The ship itself was overweight, with many parts weighing more than they should have. The crew had utilized contractors to build many aspects of the airship, and each was given specific weight guidelines to follow. For example, the lifeboat was not to weigh more than 1,000 pounds. The builder told the crew it weighed only 800 pounds when finished. But when they weighed it at Atlantic City, it approached 1,600 pounds!

By Saturday night yet another new, unexpected problem arose. The exhaust pipe burned red hot and was "belching sparks." The crew noted that the coals continued to glow for a few seconds even after they had fallen into the water. This was of particular concern because of the flammable nature of the hydrogen gas that filled the airbag, not to mention the large supply of gasoline on board. "It seemed to me only a question of time when one of those fiery, incandescent masses would lodge in some nook or cranny, set fire to the canvas, and bring our little world to an end," wrote Wellman. He ordered Vaniman to shut off the remaining engine. Vaniman called down to ask what was wrong. Upon hearing Wellman's concern, he replied, "It's been doing that all day! It looks lots worse than it is." He said there was nothing he could do but stop the motor, which Wellman did not want him to do. So he started it up again, and Wellman spent a long while watching the embers as they streamed into the sea, wondering which one might ignite the ship and end their lives. He calculated his chances of survival, and like a true optimist, increased the probability because the canvas was surely damp from the fog, which just might reduce the possibility of it going up in flames.

Navigation had been nearly impossible, because the thick fog had prevented the crew from seeing the stars. They only had a rough idea of where they were. Wellman later confessed, "I had a particular horror of landing on Long Island. To leave Atlantic City for Europe and pull up somewhere near Montauk or Newport was not to be thought of. Even a holocaust seemed preferable to a fiasco."

Despite all the troubles, Wellman and his crew were still hopeful. "We wanted to go on and fight it out as long as there was any chance—and we still believed we had a chance," Wellman said.

Sunday brought more serious problems. The "theoretical equilibrator was not proving practical at all. It was struggling along like a poor relative and straining the big craft in a manner which made Europe seem very far away," a newspaper reported.

The equilibrator behaved in a way no one expected. While the dirigible would have sailed high above the water, unscathed by rough seas, the attached equilibrator made every wave felt in the cabin. Before the voyage, Wellman had written, "How will this equilibrator serpent work in the rough sea? We confess we do not know. We believe—but are not quite sure—that it will be so 'soft' upon the waves as to give us little trouble in the way of shocks or jerks upon the airship." He could not have been more wrong.

"It jerked shockingly at the lines which held it to the *America*," said Wellman after the transatlantic attempt. "Under this stress the ship set up a rolling motion, which added to the strain and threatened the entire destruction of the craft if long continued." Every movement of the ocean yanked at the dirigible. Wellman described the situation of the crew:

> It was a dreadful night for the men aboard the ship. There was much to be done to ease the strain and all did everything possible. At times some would become exhausted and one by one the men would sleep for a time. They went to their hammocks expecting that they would awake to find themselves in the ocean, but all they wanted was to sleep and they did so.

Before the crew started out, they did not believe one could reach Europe in a dirigible without an equilibrator. "Now we know that a dirigible can not get there with an equilibrator," Wellman said. It is possible that flaws in the design could have been discovered if more extensive trials were made ahead of time. But already delayed, Wellman let accusations of "cold feet" influence his decision and he may have started his voyage prematurely.

Wellman described the trials and tribulations caused by the equilibrator in the *Mansfield News* upon his return to land: "The trailing tail held the balloon back and at times pulled it down toward the water and we had to ballast the ship at the cost of a loss of gasoline dropping to the waves. . . . The equilibrator, holding us back like a brake, made us throw out the gasoline."

By this time, the crew understood that they would not be arriving in Europe. Vaniman suggested abandoning ship in the lifeboat. Wellman was not yet ready to give up. The two argued. Knowing that they had little chance of success, Wellman felt he could not order the crew to further risk their lives. He left it up to them to decide. All but Vaniman agreed with Wellman. They would stick it out for as long as practicable. Vaniman "yielded gracefully" and continued to maintain the systems as best he could.

Sunday night was perilous with high winds and rough waves tossing the equilibrator. The crew worried that the cabin would not hold. The men were exhausted, but none could sleep. Every noise and creak of the ship raised new concerns. They kept watch of how close they floated above the ocean, and how much of the equilibrator was above the waterline. If too much of it slipped into the depths, someone would yell, "Over with something!" And a piece of the broken motor, a can of gasoline, or something else was thrown overboard.

By Monday afternoon, the crew began to focus on saving their lives. They talked about getting the lifeboat launched, and how they would steer clear of the heaving equilibrator. A new challenge came when the sun began to heat the gas and the *America* shot upward, aided by Vaniman mistakenly opening the air-valves instead of the gas-valves. The equilibrator shot out of the water and actually proved useful, as it prevented them from rising even higher. The change in altitude affected the crew's eardrums, which must have been a strange sensation for all of them, especially those on board who had never been on an airship before. Indeed, it was a bumpy ride. Simon's log recorded the experience: "On coming down our equilibrator struck the water and buried itself right up to the head. Then we bounced up like a rubber ball to the height of about 500 feet, and repeated this performance until we had once again attained our balance. It was quite a fine sensation, the White City Scenic Railway being far outclassed."

And yet, the men stayed positive, aware that they had made history merely by attempting such a feat, even if they were destined to fail. On Monday Simon wrote in his log:

> The shadow of the balloon shows up on the surface of the water. It's a delightful, exhilarating sensation, this floating between earth and sky. We hate to think we are really at the mercy of the equilibrator, and that with a little rough sea we shall be jerked into various stages of nervous collapse.
>
> We spend most of the time in the lifeboat, and we gaze, not without admiration, at the shapely craft overhead. Some day we

think there will be a fleet of aerial craft and we shall have been the pioneers.

It is a beautiful prospect this Monday afternoon—a vast expanse of dancing sunlit sea. Overhead there are blue skies flecked with white flurries of passing clouds. We are all as happy as can be. I could do with a couple months of this job.

We know the poor old *America* cannot keep afloat more than twenty-four hours at the outside. Our sudden flight aloft this morning cost us an immense amount of gas, and to an airship gas is lifeblood. The *America* will die from sheer exhaustion, a sort of bleeding to death, and before the last comes we must take to the boat.

You must never cross the Atlantic in an airship without a cat. We have found our cat more useful to us than any barometer. He is sitting on the sail of the lifeboat now as I write, washing his face in the sun, a pleasant picture of feline content. This cat has always indicated trouble well ahead.

We are doubtful at times about being able to keep up all night, but intend to have a good try. Mr. Wellman is here, there, and everywhere supervising. He has a gift for detail and is the best skipper I ever met. We simply await events.

That night was calmer, and the crew was able to get some sleep. Wellman stayed up all night, searching the horizon for the passing steamer Irwin said they should see. "I looked for her so intently, and at times so drowsily, my eyes began seeing things in the gleaming horizon or the gloomier depths covered by passing clouds," Wellman wrote. "I saw a hundred steamers, some of them full electric lighted from stem to stern; trains of cars, rushing automobiles, tall buildings shining with lights. Then I shook myself, and saw nothing at all, only to drowse again, and have more optical delusions." But at last, at 4:30 in the morning, Wellman's eyes did not deceive him. There *was* a ship on the horizon.

On Tuesday, October 18, the media picked up the story of Wellman's failure. "The first attempt to cross the Atlantic in a dirigible balloon came to grief early today," reported the *Fort Wayne News*. Just east of Cape Hatteras, the Bermuda liner *Trent* spotted the dirigible in distress. The *Manitoba Press* reported, "It is said that they realized the first day out that they could not reach Europe, but every man was determined to get as far out to sea as the *America* could take them. None of them feared death, and all are anxious

for another attempt, but along different lines and with a distinctly different type of dirigible."

Having stayed within the established shipping routes as planned, the crew always believed they would eventually find a ship passing by in the vast ocean. With little gasoline to power their engines, however, the ship could have aimlessly drifted on the winds far beyond the visual range of any passing ships. The telegraph could only send messages 75 miles from the airship, so they could have easily been cut off from all communications and lost at sea. Simon admitted later that if they had missed the *Trent*, the entire crew would likely have drowned.

In the *Lincoln Daily News*, Simon recounted the moment the crew saw the *Trent*: "Dawn was breaking when we picked up the *Trent* and she was a most welcome picture in the distance. Her lookout's eyes were very sharp, as our very first signal was answered and we then signaled her to stand by as we were in need of aid." All of the crew—including the kitten Kiddo—climbed down into the lifeboat. Irwin described what happened next in the *Lincoln Evening News*:

> After all hands had dropped into the lifeboat which swung below the *America*, I jabbed a hole in the gas bag and as the gas escaped we dropped into the ocean. When within a few feet of the water the ropes were cut and the lifeboat dropped just as we had planned. The dirigible, released of the weight, shot skyward. After we were landed on the deck of the *Trent* we could see what was left of our airship floating off to the westward at a speed of about twenty-five miles an hour.

The lifeboat launched exactly according to plan, but the rescue was not as flawless. First, the equilibrator struck the lifeboat, bruising Irwin and Loud and tearing a hole in the boat. The gash was above the waterline, so it posed no immediate threat. Second, the *Trent* had been steaming ahead at full speed to keep up with the wind current propelling the airship. They could not come to a complete stop quickly, causing the *America's* crew to fear that their lifeboat would be cut in two. For a moment, they contemplated jumping overboard and swimming in the opposite direction of the ship's gigantic propeller. Thankfully the ship was finally able to slow down, and the crew threw a line to the survivors. But Wellman's hands were burnt and cut from trying to hold on to it. The crew of the *Trent* made several more attempts to throw a rope, and finally a connection was established between

the tiny lifeboat and its massive rescuer. As the survivors climbed aboard the ship, the steamer's passengers and crew broke into cheers.

The New York Times and London Daily Telegraph chartered a tug for the families to meet the crew of the America. On board were Mrs. Vaniman, Mrs. Loud (mother of Mrs. Vaniman and Louis Loud), Mrs. Wellman, and four of the five Wellman daughters: Ruth, Rae, Rita, and Rebecca. Despite the failure of the voyage, Wellman and his crew were treated like heroes. The Lincoln Evening News reported that "When the Trent docks, Wellman and his companions will be greeted by a half score of theatrical agents, armed with blank contracts for vaudeville appearances, lecture tours and other engagements. Even the mascot cat of the America will not be neglected by the managers." Indeed, the crowds came to welcome the America's crew back home. There were receptions and interviews with the media. The Times featured six full pages about Wellman and the crew in the October 20 edition.

Lecture and vaudeville offers came pouring in. Even Kiddo the cat had his time in the spotlight. He was exhibited on "plush cushions in a gilded cage" at Gimbrel's store. Wellman received hundreds of congratulatory telegrams, two of which Mabley writes were "especially gratifying" for Wellman:

> Hearty congratulations. You have done a grand and noble thing.
> —Peary

> I take this opportunity of heartily congratulating you upon your safe return, and your more than interesting experiences. I hope to be able to hear about them from you yourself, and to extend my congratulations in person; you have performed a noble feat. With hearty good wishes, faithfully yours,
> Theodore Roosevelt

By some accounts, Wellman was not disheartened by the trip, but was instead inspired to try again. He recognized the flaws of the equilibrator, and he and Vaniman began working out plans for a new design on the decks of the Trent. In his log, Simon wrote, "All of us felt gratified by our novel trip and all are fully prepared to take part in another attempt. I think I am right in saying that our appetites have been whetted by this taste of transatlantic travel by the air route, and we are certain that when we try again with an improved airship we shall be successful." The year after their voyage, Wellman himself wrote, "That the Atlantic Ocean can be crossed by

an airship of the motor-balloon type there is no doubt whatever."

But Wellman would not make another attempt to cross the Atlantic. In 1911 he wrote, "It is even worth while to try and fail, because failure often teaches as much as success. Of course it is far better to try and win." It is unclear why he didn't try again. Financial backing may have been a problem. Or perhaps the nation's new fascination with the "aeroplane" detracted from the dirigible's merits. For whatever reason, Wellman appears to have given up his second dream, again mired in failure. He never again boarded an airship or a plane.

Wellman did make aviation history, although not in the way he had intended. With the destruction of the *America*, he became the first captain of an airship to be wrecked at sea. On a more positive note, the crew did break all records for manned flight in a powered aircraft. They were in the air 71 and a half hours and traveled 1,008 miles. S. H. Mathews of Hot Springs, Arkansas, wrote to the *Literary Digest* in 1919:

> No greater feat of daring, no greater nerve displayed, no greater gamble with death was ever made than by Wellman, Vaniman, Irwin, Loud, Simon and Aubert, Americans, on October 15, 1910, when they hopped off from Atlantic City, New Jersey in the dirigible airship *America* in an earnest effort to cross the Atlantic. Traveling in the air, over the Atlantic, continuously for three days they established a record of 1008 miles in 71 ½ hours (37 hours aloft being the former record of a Zeppelin) When we consider that Wellman's attempt to cross the Atlantic was made nine years ago, in an airship 228 feet in length, with a gas-bag capacity of only 345,000 cubic feet with two small motors only 80 horsepower each, when the non-stop airplane record was at five hours; and further consider, that the air navigators of today have the advantage of a world of knowledge gained from war experience and the progress of science and invention . . . we are inclined to the belief that Wellman and the brave crew of the *America* deserve greater credit for the display of nerve of the pure and unadulterated kind.

Wellman died January 31, 1934, at the age of 75. He had been ill for three months prior to his death. His obituary gave his expeditions top billing over his accomplishments as a journalist. It also mentioned a peculiar case that was pending, Wellman's claim against the Interborough Rapid Transit

Company, which was in receivership: "The explorer committed a survey of the company in 1918 as a result of which he alleged the company won a $404,557 judgment from the city. He claimed an agreement with the company entitled him to $40,569 and other undetermined sums."

Wellman's attempt to cross the Atlantic may have been a colossal failure, but it captured the spirit of adventure that dominated his personality. Despite the challenges, Wellman at least made an effort to realize his dream. The same spirit and drive influenced another Canton man to take the impossible and make it possible. Both would accomplish great feats, and then stand by idly as others brought their goals to fruition.

4. Resolved That Man Will Fly
The Martin Glider

Long before the Wright brothers conquered the problem of "practical flight," some of our country's greatest minds were wrestling with the same question. How could humankind shed the bonds of gravity and soar among the clouds? The soul of an inventor was stirred by these questions, and another young Canton boy set out to find the answers.

William H. Martin was born on January 21, 1855, in Canton Township to Charles and Delilah Smith Martin. His father was a farmer who operated a rope-making business on the side, carrying on a family tradition that spanned several generations. The Martins had immigrated to the United States in 1745 from Germany, and moved to Stark County in 1831. Charles bought a farm just outside of town, but his property was still within the Canton Union School District.

Young William had Anna McKinley, the U.S. president's sister, as a teacher. Once Miss McKinley called Martin to the front of the room. He allegedly leapfrogged over a chair in the aisle on his way up, and Miss McKinley told him to go back and come up again. Being a bit of a jokester, Martin repeated his actions exactly and leapfrogged the chair again, causing Miss McKinley to rephrase her request to "come up correctly." The third time, he did as he was asked.

Martin began "making things" at the young age of eight. He invented a rope spinning machine that was a great help to his father in the family business. When he was 17 years old, his father bought the 78-acre Colbeck farm, north of 30th Street and east of Martindale Road, which was named for the Martin family.

On October 10, 1878, Martin married Mary E. Pontius when he was 24 years old, joining three early pioneer families. The Pontius family had come to Stark County in 1816 and had intermarried with the Essig family, who settled in this area in 1806. Martin purchased a farm near his father and began working the land. In his spare time, he studied engineering and surveying. He had a reputation for being painstaking and accurate, so it was a natural choice for Plain Township officials to commission him to draw a map of the township. It was so well done, the publishers of a Stark County

atlas used Martin's map in 1896. From 1883 to 1885, Martin worked as the county surveyor. He was a member of the school board and attended the Seventh Day Adventist Church.

Amid all of his other activities, questions about human flight kept calling to him. His inquisitive mind led him to join a debating society at Brush College near Canton. One cold winter evening, their meeting had gotten rather dull toward the end. The group asked him to suggest a topic, and he said, "Resolved that man will fly." At that time, human flight was such an impossibility, none of the debaters had even heard of something so silly. Everyone began to laugh at him.

"I was the only one who would take the affirmative side of the question," Martin later recalled. "They called me a fool—but they called Lindbergh a fool too, until he landed in Paris, and now look at what people are saying. He is the man of the hour." Martin enthusiastically embraced this new challenge. "We had two weeks to prepare our arguments, and in that time I read every encyclopedia and book upon flying I could find."

The night of the debate finally arrived. Well prepared, Martin made his argument alone against a team of three other members. "The judges were to give a decision on the logic of the argument disregarding their own opinion and they decided in my favor," he said. "My three opponents had not thought it necessary to prepare much of an argument on such a preposterous question."

One can imagine Martin's brilliant mind countering point after point from the unprepared opposition, convincing a room full of naysayers that it was only a matter of time before man would fly. "That debate set me to thinking," he said, "and I have been thinking ever since." No doubt inspired by his success, Martin began to experiment with toy airplanes powered by rubber bands. Although he was never able to find a company willing to produce his toy, he was able to glean valuable information from his tiny models that would prove useful later on.

Meanwhile, Martin was becoming a successful farmer, adopting all the modern methods of agriculture. He owned the first grain reaper and binder in Plain Township. In time, he expanded his operation by acquiring 62 acres on Harrisburg Road from his father-in-law, John Pontius. He and Mary had six children together: William, George, Edith Blanche (who died at six years), Mary, and twins Thoburn and Thomas (Thomas died at three months). Sadly, his wife passed away on September 17, 1893, when she was just 34 years old. Two years later he married Mrs. Almina Holtz Pontius, the widow of Thomas J. Pontius. She and Martin had three more children together: James, Charles, and Eudora.

Martin continued to experiment with flight. At the same time, the Wright brothers were quietly testing their own theories in Dayton. On December 17, 1903, Orville Wright flew their machine 120 feet for 12 seconds in a 27 mile-per-hour wind at Kitty Hawk, North Carolina. Wilbur Wright's flight went 852 feet for 59 seconds. The brothers patented their plane May 22, 1906.

But the Wright Flyer was a biplane design, meaning it had two wings, one above the other. Martin's revolutionary idea was based on a single wing design, or monoplane. It was the first of its type in the world. According to Stark County Historian E. T. Heald, "He struck out boldly from the biplane designs in use by other inventors and adopted the monoplane form, with balancing wings forming a V below the main wing to give it stability and safety." He used a lightweight wood, covered in English broadcloth sewn by Almina.

Martin built his glider over the winter of 1908–1909. When it was ready for a test flight, snow caused him to add sled runners to the bottom of it instead of wheels as originally planned, although he would add wheels later. The glider had no engine, so it could not move under its own power. Martin hooked his contraption to Old Billy, the family horse, and his son George got the animal moving. William H. Martin II later joked that his grandfather had invented "the first one-horse-power airplane." Old Billy began to run downhill, pulling the plane behind him. It rose 25 feet in the air and glided 200 feet before the horse slowed his pace and Martin floated back to earth. Charles Martin later recalled that the plane "came down like a feather." He said if he had shut his eyes, he would not have known when the plane touched the snow. Almina piloted many future tests, because she weighed less and presumably could take the glider higher and farther, thus becoming the first woman in the world to fly a heavier-than-air machine.

Certainly Martin remembered the ridicule he had suffered at the hands of the debating society years earlier when he had suggested that man would soon fly. So he kept his little project a secret, building it inside a barn, beyond the prying eyes of his neighbors. But he could not hide the spectacle of the trial flight, and soon crowds flocked to his field to gawk at the wondrous machine he had built. No one in Canton had ever seen anything like it. People stared in bewilderment as one of their own flew like a bird.

Martin's invention was indeed a novelty. The Wrights tested their biplane machine for the government in 1908, and locally, Cantonians were still enthralled with the balloon activities of the Aero Club. Over the next few weeks, the Martins made over 100 more test flights. All members of the family got involved—even the pet dog! Most of the tests were successful,

but on one occasion the sled runners hit a bare spot in the snow causing the glider to swerve and hit a fence. One of the wings was slightly damaged, and the tests were suspended while Martin set about fixing it.

Without a doubt, Martin was thrilled with the success of the invention he had carried from mere dreams into reality. But he longed for the opportunity to demonstrate his glider for a larger audience, beyond the local scene in Canton. Lacking the money to finance such a trip, Martin turned to William A. Hoberdier and his brother to help him pay for travel expenses. In May 1909, Martin attended an air meet at Morris Park, New York, and was one of the few entries that actually got into the air that day. Thousands of skeptical onlookers would soon be shocked and amazed by the thought that man could indeed fly! Heald recorded this account of the day, published in a New York newspaper:

> George Thompson, an ex-jockey, traveled around the old Morris Park racetrack twice yesterday in the Martin aeroplane, just arrived from Canton, Ohio. The aeroplane is bereft of a motor so the motive power was supplied by an automobile. The flying machine was hitched to the motor car by a rope about 100 feet long and towed around the mile long track at a speed of 30 miles an hour.
>
> When going against the wind it rose to a height of about 15 feet. On an average it maintained itself in the air at an altitude of about 10 feet. Whenever the automobile increased its speed the aeroplane would receive such momentum that it would attempt to dash ahead of its guide.
>
> The Martin aeroplane is one of the most curious contrivances . . . among the 14 machines at Morris Park. It is 30 feet wide and about 30 feet long. Instead of consisting of the usual rigid planes top and bottom, it has one wide top plane and two planes inclined toward the bottom in the shape of a V. These planes constitute what is known as the dihedral principle and give the apparatus stability while in flight.
>
> When the machine was in flight yesterday . . . it swooped around the track behind Oral A. Parker's automobile [and] swayed drunkenly from side to side and often narrowly missed collision with an obstructing tree, but it showed very clearly that it would always right itself before coming to the upsetting point.

Later, Martin flew the glider himself, although the winds were quite high and dangerous to those early flying machines. In fact, weather conditions were so adverse, Martin would not permit his wife to fly that day. In an article in *The Repository* almost 20 years later, Martin recalled, "Other men who were scheduled to perform refused to go up and the crowds began to grow impatient. When 50,000 people grow impatient, something has to be done, so I finally agreed to fly myself. The plane swept along like a bird until we reached the end of one of the grandstands when a terrible gale of wind struck it."

What happened next might have killed the pioneer aviator if he had lacked the skill necessary to perform well under pressure. The rope tethering the glider to the automobile suddenly snapped, and Martin's machine was now flying freely in a manner in which it had never been tested. Despite the danger, Martin had faith in his invention, saying:

> My machine is so constructed that it cannot nose dive, but the rope broke, and we started down. I had two chances, either to land on the fence or guide the machine through the rails, which were fairly wide apart. I chose the latter. For a moment it seemed we would be dashed to pieces, but my plane responded to my efforts to guide it and we crashed through the opening and stopped. I escaped without a scratch.

Martin had tremendous faith in his plane's safety. Back in Canton that fall, his eight-year-old granddaughter Blanche made some solo flights in the glider. She flew for 75 feet, becoming the youngest person in the world at the time to pilot a heavier-than-air machine.

Martin was surely aware of the success of the Wright Flyer and understood that without an engine, his invention would not progress beyond a novelty. He set about trying to find one, writing to Frank S. Lahm in France for advice. Lahm responded that the only successful motor he could suggest was very expensive—$10,000, an exorbitant price in 1909! Lahm told him a smaller engine would likely appear on the market soon, and advised him against purchasing a used engine, as they were very unreliable. In his letter to Martin, Lahm wrote, "I have mentioned your machine to journalists in interviews in New York and in this city [Paris]. You no doubt have seen some of the articles but I enclose a couple. I trust you are meeting with good success as a flyer, and to hear soon you have applied a motor."

Martin continued work on his plane, albeit without a motor. "I finally applied for a patent, and after six weeks the answer came that my idea was a

novel one—that meant new—and I had a chance." Martin received patent #935384 for his flying machine on September 28, 1909, having employed the assistance of local patent attorneys Harry Frease and F. W. Bond.

The drawings Martin provided for his patent show it with a propeller and a motor, which were never added. He explained the principles behind his invention in great detail, stressing his invention's means of "righting itself:"

> Now my invention comprehends two general principles, one serving to effect the automatic adjustment of the aeroplane to such an angle to the horizontal as to cause it to have a buoyant tendency from the resultant upward pressure against its lower sides. . . . The other principle . . . is to provide for the automatic balancing, or self-righting quality of the aeroplane as against the tendency to dip sidewise about its axial line of flight.

Martin reportedly carried his patent certificate in his pocket at all times. In 1927, a newspaper article reported, "It is yellowed now with age, and the leather case . . . is well worn, but it is displayed with pride by this veteran inventor." The article goes on to discuss how Martin's designs likely were the model for the design of Charles Lindbergh's famous plane, the *Spirit of St. Louis*. The article quotes J. H. Bishop and H. F. Frease, of the Frease & Bond firm of patent lawyers, as saying, "It should be of interest to Cantonians to know that . . . patent 935384 upon an airplane, was issued to Mr. William H. Martin, Canton, Ohio, a pioneer inventor of airplanes, upon a type of airplane which is substantially duplicated in the Belanca plane 'Columbia' and Captain Lindbergh's plane 'The Spirit of St. Louis.' "

Having exhausted all of his options in securing a motor for his glider, Martin regretfully disassembled his plane and stored it in the barn. Seven years later he purchased a French Le Rhone rotary engine, but a series of bizarre mishaps prevented him from mounting it to the glider. His son Thoburn planned to install it but was killed in a sandslide in 1916 before he finished the project. Later Martin secured the help of French World War I ace Captain Charles Nungressor, but he was killed in an attempted trans-Atlantic crossing in 1927, the same year as Charles Lindergh's famous successful flight.

It seemed a motor was not meant to be for Martin's plane. Nearly 20 years earlier, his invention had been a first in the aeronautical world, but by the late 1920s, it had been surpassed by many other inventors' creations. He had made quite a media splash when he debuted the glider, but it had

Frank S. Lahm was born in Canton on April 25, 1846. He is pictured here as a young man, probably around 1860.

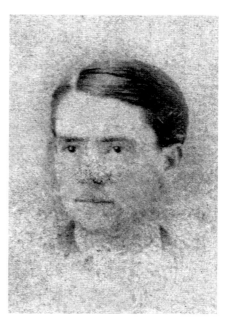

Young Frank attended Canton Union School. This document, dated July 4, 1858, allowed him to enter the "Grammar Department."

Frank S. Lahm married Adelaide Way Purdy in Mansfield, Ohio, in February 1875. She died unexpectedly in 1880 after giving birth to their third child, who also died six weeks later.

Frank S. Lahm posed for this portrait with his children Frank Purdy and Katherine Hamilton Lahm in 1888. Although each child was raised by a different aunt, and Frank himself spent most of the year in Paris, the family remained close.

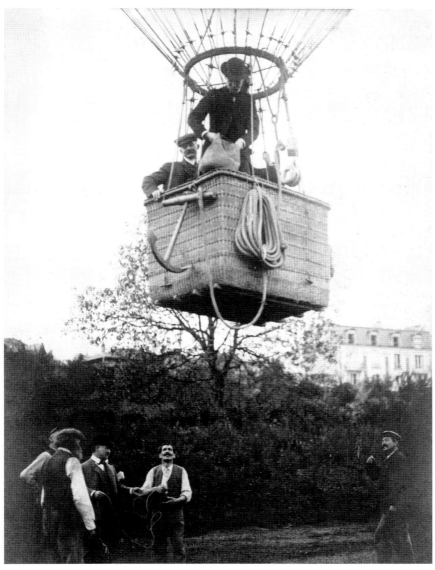

While living in Paris, Frank S. Lahm became interested in the activities of the French Aero Club. After joining the club, Lahm purchased his own balloon, which he named Katherine Hamilton after his daughter. He is seen here making an ascension in his balloon on June 19, 1906.

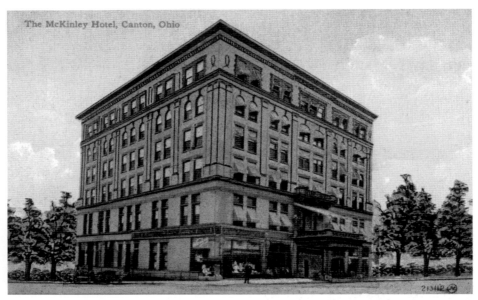

The McKinley Hotel, Canton, Ohio

Frank S. Lahm invited his closest friends to dinner at the McKinley Hotel on December 9, 1907, to ask them to form the Aero Club of Ohio.

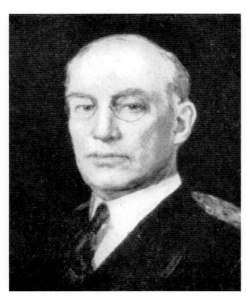

The Timken family began their business in St. Louis, where they manufactured carriages and wagons, with roller bearings specially designed to make the ride smoother. With the invention of the automobile, H. H. Timken (pictured here) wisely chose to begin manufacturing roller bearings for cars. As the business continued to grow, the family chose to expand in Canton for its proximity to both the steel industry and the young auto industry. On September 23, 1901, the Timkens bought five lots on Dueber Avenue and 20th Street SW. Just six years later, H. H. Timken helped found the Aero Club of Ohio.

Joseph M. Blake was a local attorney who served as the Aero Club's secretary and treasurer. He became president of Central Savings Bank and was active in the Stark County Bar Association.

Zebulon Davis was at the McKinley Hotel and became a charter member of the Aero Club of Ohio. Davis founded the Diamond Portland Cement Company in 1892 and served as its president for 39 years. Always on the cutting edge of technology and transportation, he owned and drove the first automobile in Canton.

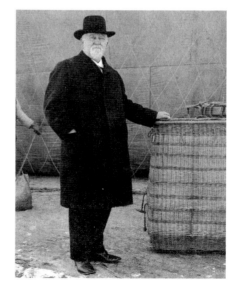

Johnson Sherrick served as president of the Aero Club of Ohio. He made his first ascension on July 23, 1908, at the age of 67.

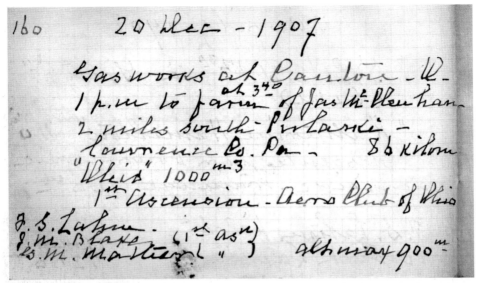

Frank S. Lahm recorded the first flight of the Aero Club of Ohio in his journal on December 20, 1907.

Telegrams were sent from aero clubs across the country to congratulate the Aero Club of Ohio upon the occasion of its founding.

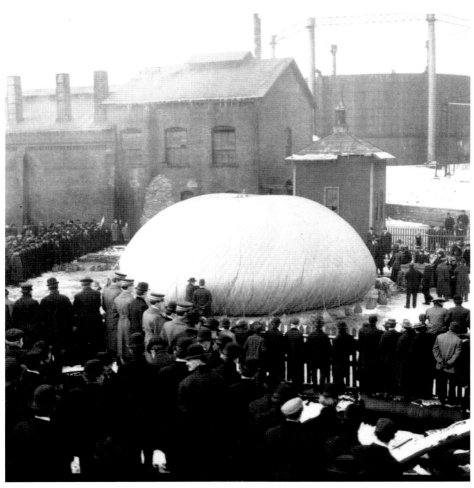

The Aero Club's activities drew quite a crowd. This balloon was filled with 35,000 cubic feet of gas in a large vacant lot near the old Canton Gas Works on Walnut Street.

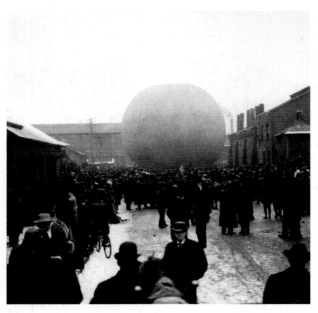

The Aero Club's balloons were filled with natural gas, not hot air. They were also more spherical than most balloons today.

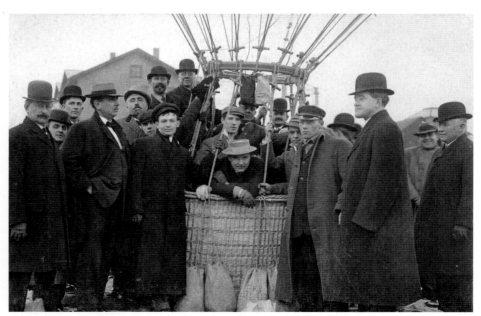

Members of the Aero Club ready to ascend in the Sky Pilot, *whose name is visible on the bags of ballast in front of the basket.*

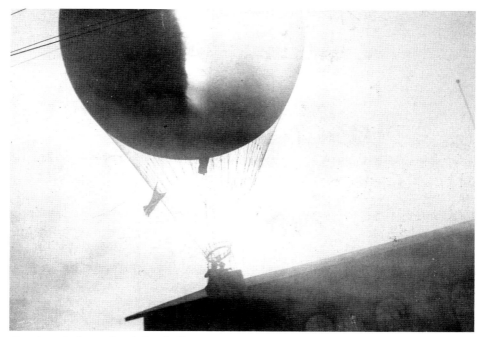

Frank P. Lahm piloted this balloon ascension in 1909. Buildings close to the balloon take-off site were always a problem.

The Aero Club of Ohio even had its own march, composed in 1909 by C. L. Barnhouse.

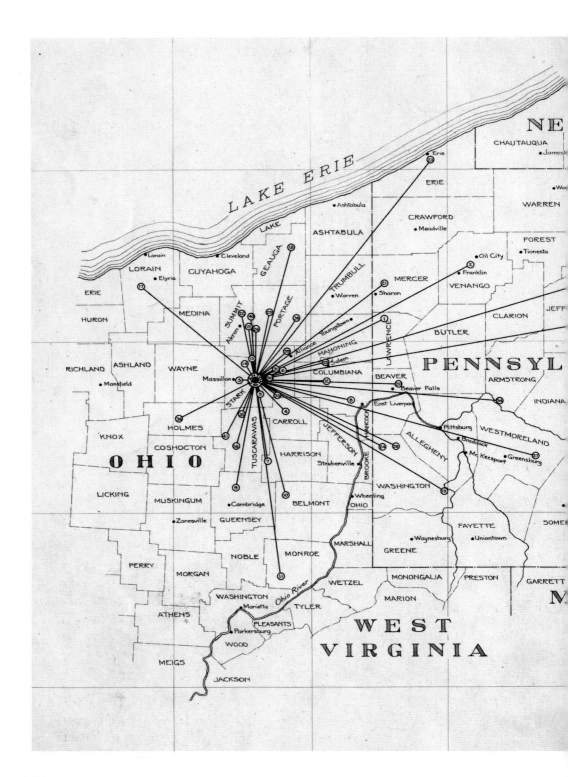

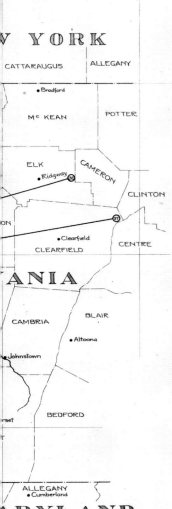

Flight No.	Date	Landing Place	Distance In Miles
1	Dec. 20,'07	Pulaski, Pa.	154
2	Jan. 28,'08	Oil City, Pa.	92
3	June 6,'08	Sippo Lake, O.	6
4	July 22,'08	New Harrisburg, O.	18
5	July 23,'08	North Industry, O.	4
6	July 25,'08	Louisville, O.	9
7	Aug. 8,'08	Stillwater, O.	35
8	Aug. 22,'08	Millport, O.	28
9	Sept. 7,'08	Kimbolton, O.	46
10	Sept. 7,'08	Piedmont, O.	51
11	Sept. 12,'08	Lewisburg, O.	82
12	Sept. 22,'08	Salem, O.	29
13	Sept. 24,'08	Cairo, O.	8
14	Sept. 25,'08	Mc.Donaldsville, O.	8
15	Sept. 26,'08	Akron, O.	22
16	Oct. 2,'08	Roswell, O.	25
17	Oct. 21,'08	Oberlin, O.	58
18	Oct. 24,'08	Huntsburg, O.	56
19	Oct. 31,'08	Coal Center, Pa.	102
20	Nov. 7,'08	Beaver Falls, Pa.	57
21	Nov. 14,'08	Transfer, Pa.	62
22	Nov. 21,'08	Cuyahoga Falls, O.	28
23	Nov. 23,'08	Erie, Pa.	120
24	Dec. 5,'08	Hanlin, Pa.	50
25	Dec. 23,'08	Salem, O.	30
26	Dec. 25,'08	Mogadore, O.	19
27	Jan. 1,'09	Ligonier, Pa.	140
28	Apr. 24,'09	Bulger, Pa.	63
29	May 12,'09	Ravenna, O.	28
30	June 19,'09	Osnaburg, O.	5
31	June 26,'09	Louisville, O.	8
32	July 2,'09	St. Marys, Pa.	148
33	July 5,'09	Malvern, O.	14
34	July 16,'09	Apollo, Pa.	105
35	July 31,'09	Zoar, O.	13
36	Aug. 7,'09	Millersburg, O.	33
37	Sept. 2,'09	Cataract, Pa.	180
38	Sept. 6,'09	Palmyra, O.	30
39	Sept. 6,'09	Alliance, O.	20
40	Sept. 9,'09	Kent, O.	25
41	Sept. 11,'09	Canal Dover, O.	25

BALLOON FLIGHTS

UNDER THE AUSPICES OF

THE AERO CLUB OF OHIO

CANTON, OHIO, - U.S.A.

Organized, December 1907, by Mr. F. S. Lahm

Compiled, September 25, 1909
By R. N. Cole

Frank P. Lahm commissioned this map to display at the aeronautical exposition in Paris showing the routes and landing places of all ascensions made from Canton up to that time. The map was compiled September 25, 1909. It lists the date of the flight, the landing place, and the distance travelled in miles.

75

Frank S. Lahm drew this undated humorous account of how he and his son became interested in aviation. The sign at the left reads "Lahms Bird House." The central figure says, "I wonder if that ain't where the Lahm boys got their ideas of flying?"

Frank S. Lahm counted many important people among his friends. William R. Day, a close personal friend of President McKinley and later a Supreme Court justice, composed this handwritten letter to express his regrets for an invitation to Turkeyfoot Lake.

Lahm records a visit to the home of Orville Wright and Katherine, his sister, on October 25, 1923. "Their home seems to me one of the most attractive I ever saw," he wrote.

The Wrights' home in Dayton as it appears today. It is still in private hands and is not open for tours. From the author's personal collection.

Frank S. Lahm recorded a visit from the Wrights on August 23, 1924. The next day he writes, "We made a trip around the lakes in the 'Crescent.'" Lahm entertained the Wrights at dinner, and they left the following day.

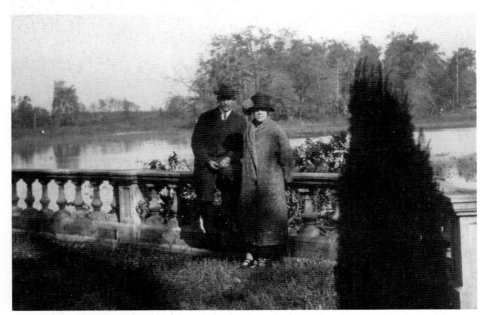

Orville Wright with his sister Katherine at Frank S. Lahm's summer home on Turkeyfoot Lake in September 1930.

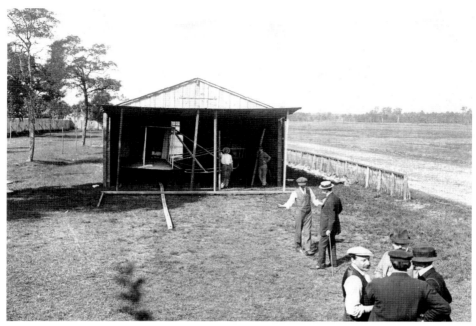

Frank S. Lahm (with cane) talks to Wilbur Wright in France in October 1908.

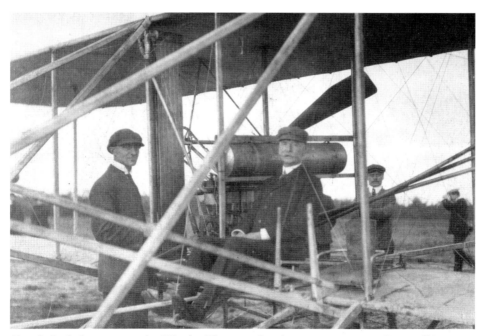

Frank S. Lahm sits in the Wright Flyer on October 18, 1908, at Camp d'Auvours, France. Wilbur Wright stands next to him.

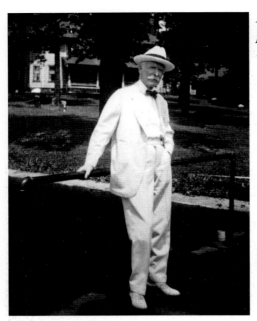

A dapper Frank S. Lahm posed for this photograph at his beloved Turkeyfoot Lake.

Frank S. Lahm climbs into an open-cockpit biplane with an unidentified Army pilot in January 1925.

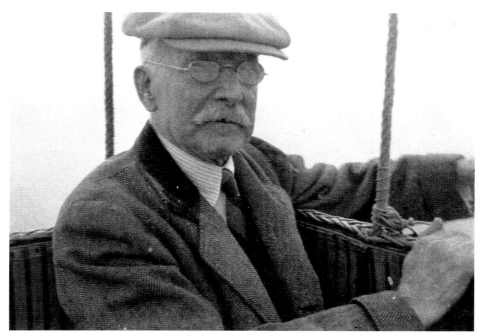

Frank S. Lahm was photographed as he made his last balloon ascension on June 27, 1929. He was 83 years old.

Frank S. Lahm recorded each transatlantic crossing in his journal. Here he records his 50th trip in January 1930. His fare was $157.

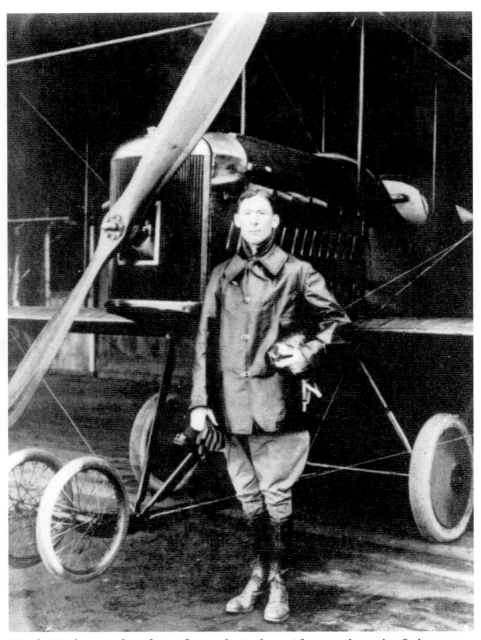

Frank P. Lahm stands in front of an early airplane. After completing his flight training with the Wright Brothers, Lahm was the only military officer licensed to fly a balloon, dirigible, and airplane. He and Lt. Frederic E. Humphreys made up the first military aviation branch in the world. (Courtesy National Archives.)

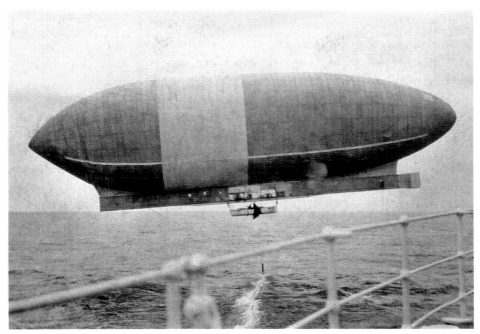

Walter Wellman's airship America, *as seen from the deck of the* Trent *shortly before the rescue of the crew. (Courtesy National Air & Space Museum.)*

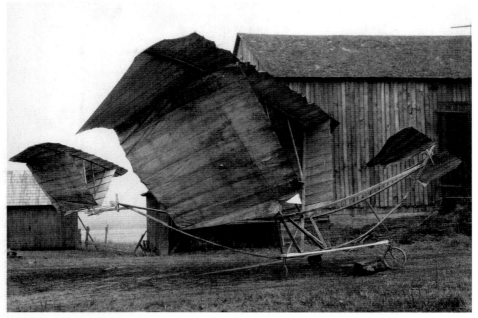

William H. Martin's glider was a revolutionary monoplane design. He donated it to the Smithsonian, where it was displayed alongside the Spirit of St. Louis.

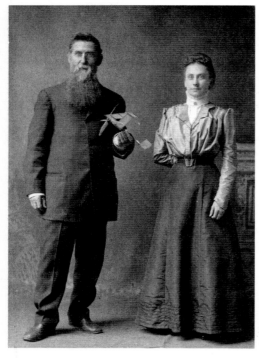

Martin's wife Almina was the first woman to fly a heavier-than-air machine. Martin is holding one of his early model planes.

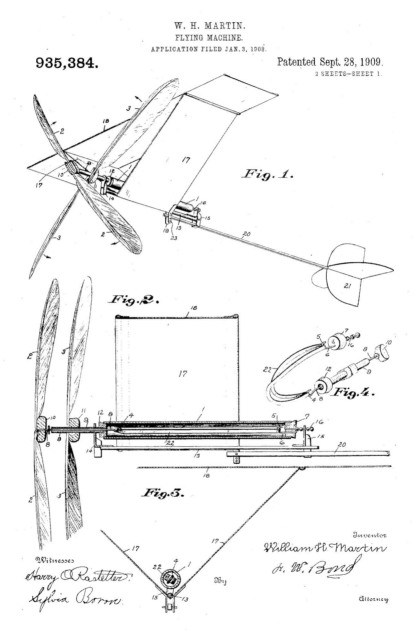

W. H. MARTIN.

FLYING MACHINE.

APPLICATION FILED JAN. 3, 1908.

935,384.

Patented Sept. 28, 1909.

2 SHEETS—SHEET 1.

Fig. 1.

Fig. 2.

Fig. 4.

Fig. 3.

Witnesses

Harry C. Rastetter.

Sylvia Boron.

Inventor

William H. Martin

Jr. W. Bond

Attorney

Martin received patent #935384 on September 28, 1909. His drawings show a model powered by two propellers and a rubber-band "engine."

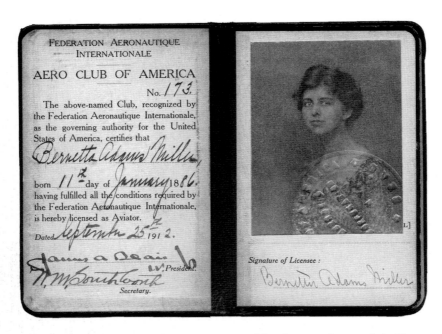

Bernetta Miller received pilot's license 173, issued by the French aero club. She was the fifth woman in the nation to learn how to fly. She is pictured below in her flight gear.

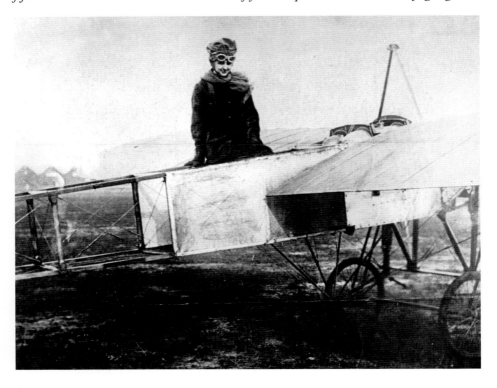

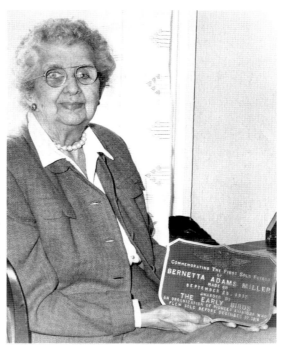

In her later years, Bernetta Miller was honored as a member of the Early Birds, an exclusive organization of aviators who made a solo flight before December 17, 1916. She donated her Early Birds plaque, pictured below, to the Stark County Historical Society, which today operates as the Wm. McKinley Presidential Library & Museum.

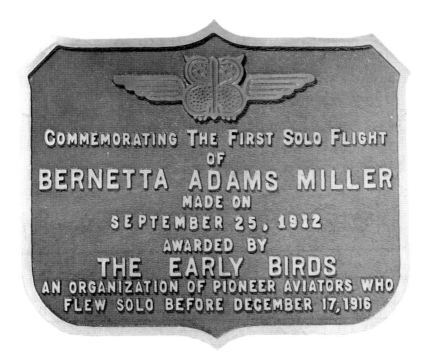

COMMEMORATING THE FIRST SOLO FLIGHT
OF
BERNETTA ADAMS MILLER
MADE ON
SEPTEMBER 25, 1912
AWARDED BY
THE EARLY BIRDS
AN ORGANIZATION OF PIONEER AVIATORS WHO
FLEW SOLO BEFORE DECEMBER 17, 1916

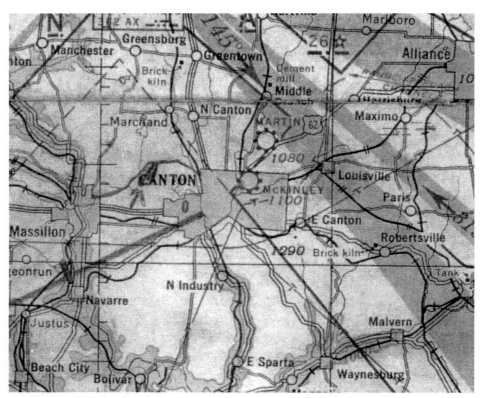

This chart shows the locations of Martin Field and McKinley Field, two early airfields that no longer exist. (Courtesy E. H. Cassler, via Jim Keller.)

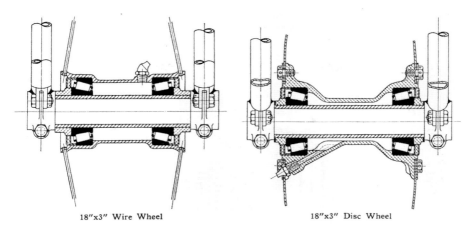

18"x3" Wire Wheel 18"x3" Disc Wheel

This drawing shows a typical tail wheel bearing layout for both a disc wheel and a wire wheel. It originally appeared in December 1928 in a publication called Timken Bearings for Aviation. (Courtesy The Timken Company.)

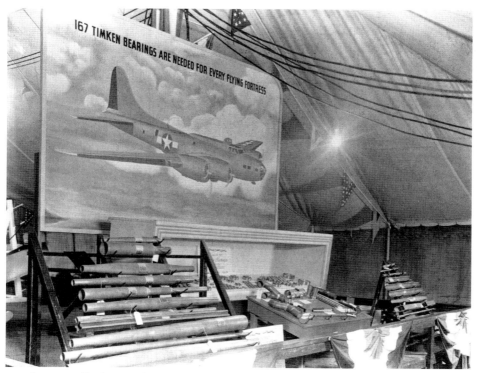

Timken proudly displayed its support of the war effort in billboards, advertisements, and displays like this one, showing the number of bearings used in the plane as well as a number of the components produced with Timken steel. (Courtesy The Timken Company.)

Steel FIT FOR THE HINGES OF HELL

Developed by Timken to send Jet Propulsion Planes Plunging Through the Sub-Stratosphere

Jet Propulsion Planes that are plunging through the sub-stratosphere at terrific speeds are the results of the unwearying patience of scientists working in collaboration with Army Air Force Engineers.

Perplexing, brain-twisting problems had to be overcome. New improved materials had to be found that could meet the exacting demands of a practical Jet Propulsion Plane.

A new steel was required for the turbine wheel. One that could operate successfully at extremely high temperatures. In addition it had to have outstanding strength to resist the terrific centrifugal force developed by the turbine wheel spinning furiously at unbelievable speeds. Ordinary steels were like putty under such a combination of forces.

A tough problem. It sounded like the specifications of steel for the Hinges of Hell. But Timken metallurgists had the solution ready. The Timken Alloy Steel developed for the Turbosupercharger, that enables our bombers to fly at unprecedented heights, was able to withstand the almost impossible demands of this turbine wheel. Steel that is making the world gape in wonder at the amazing performance of Jet Propulsion Planes.

You also can depend on Timken's metallurgists to help solve any of the problems you have to face in developing your own products. Steel and Tube Division, The Timken Roller Bearing Company, Canton 6, Ohio.

TIMKEN
TRADE-MARK REG. U. S. PAT. OFF.
ALLOY STEELS

Timken metallurgist Martin Fleischmann developed a new high strength steel alloy that performed well at high temperatures, allowing planes to fly at higher altitudes. (Courtesy The Timken Company.)

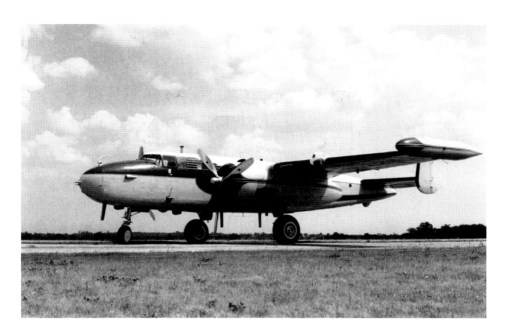

In 1953, Timken acquired a North American B25 bomber (above), which had been converted to an executive plane by Continental Oil Company. In 1957, H. H. Timken Jr. purchased a twin-engine Morane-Saulnier 760 Paris (below) from a French manufacturer, the first privately owned jet in the country. Timken's wife Louise also flew it, becoming the first woman qualified to fly jets. (Both photos courtesy The Timken Company.)

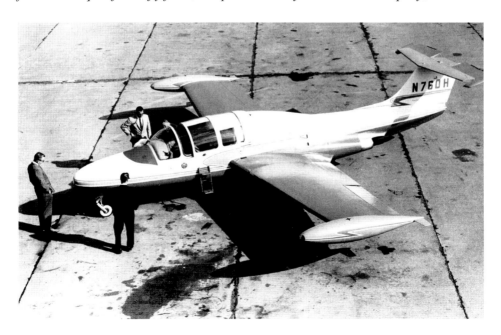

Lights shine on Runway 1, not long after Akron-Canton Regional Airport opened in 1948. (Courtesy Akron-Canton Regional Airport.)

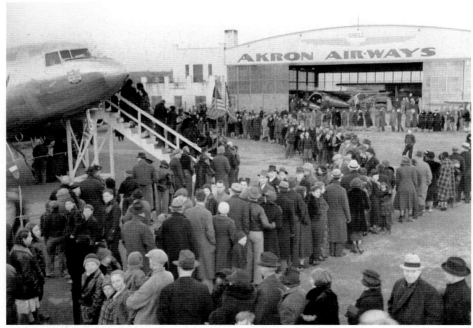

Air show visitors lined up to see the latest in aviation technology as well as historic aircraft. (Courtesy Akron-Canton Regional Airport.)

Jean Greenham Adams sits in front of the airport's brand new ASR-4 airport surveillance radar in January 1962. Adams graduated from McKinley High School, went to college, and joined the Civil Aeronautics Administration at Akron Municipal Airport in 1945 during World War II. She moved to Akron-Canton in 1948. Many women became radar operators during the war, and several made lifelong careers as air traffic controllers. Adams was also a private pilot. (Courtesy Akron-Canton Regional Airport.)

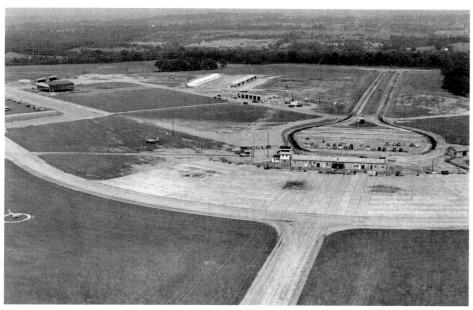

The old "Quonset hut" terminal was original to the airport. (Courtesy Akron-Canton Regional Airport.)

In 1959, ground was broken for a new terminal building to replace the "sheep shed" or "Quonset hut" that was now much too small for the number of people who were using it. The new terminal was built 300 feet east of the old one, and covered the existing parking lot at that time. The aerial photograph below shows another view of the construction.(Both photos courtesy Akron-Canton Regional Airport.)

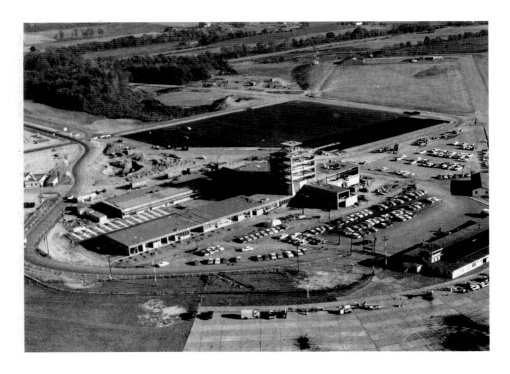

The interior of the new terminal, shown here in 1962, was very modern. (Courtesy Akron-Canton Regional Airport.)

Jack Doyle, left, came to Akron-Canton Airport in 1968. In 1981 Fred Krum, right, was promoted to airport director, becoming the youngest director of any commercial airport in the country. (Courtesy Akron-Canton Regional Airport.)

A multi-phase improvement project drastically changed the appearance of the airport. The old beltway was replaced by escalators, and a skylight was added. (Courtesy Akron-Canton Regional Airport.)

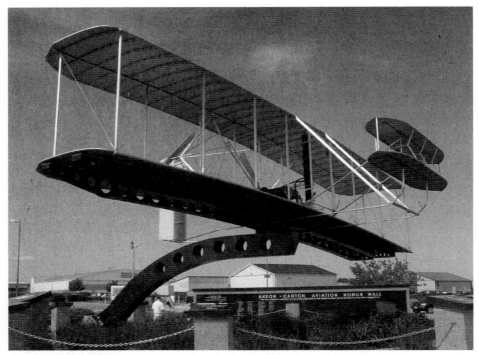

On December 17, 2003, the 100th anniversary of flight, volunteers dedicated Aviation Park at the Akron-Canton Regional Airport. The centerpiece of the project was an exact replica of the Wright Flyer, which was created from the original plans in the Smithsonian's collection. From the author's personal collection.

been relegated to the sidelines as better-funded projects soared ever higher. Martin could no longer justify the expense of outfitting his machine with a motor and gave up on his dream. Later, he gave his engine to Harry Renkert in exchange for some flying lessons for his grandson.

Martin turned his focus to other things, and the glider stayed packed away in the barn, all but forgotten. In 1928 Representative John McSweeney, who held William McKinley's seat in Congress, heard about the glider and came to see it. He reported his findings to the curators at the Smithsonian. With Martin's permission, the glider and a smaller model of it, later dubbed the "Martinette," were crated up and shipped to Washington, D.C. Such a high profile donation to the country's premier museum was a source of local pride, and the story of Martin's invention was resurrected. One article described the transport and arrival of the precious invention: "It was packed carefully and bags of straw placed in the crate in order that its framework would not be damaged. The plane arrived in excellent condition, was reassembled, in accordance with Martin's directions and now hangs in the corner of the institute where it is attracting much attention."

The glider arrived in Washington on January 19, 1929, nearly two decades after those first trial flights on the Martin farm. After a great deal of research, the Smithsonian determined that it was indeed the first of its kind. In a letter to Martin, Paul Edward Garber, who was in charge of the Smithsonian's mineral and mechanical technology collection, wrote, "It is of great value to the collection as a mechanical specimen. The 'Martinette' model is one of the features in a case devoted to the background of aviation and is exhibited adjacent to models made by such experimenters as Piachaucourt, Penaud, Dandrieux, Launoy, and Bienvenue." Garber also sent along photos, showing Martin how the glider was unpacked and placed in position. Martin was quoted as saying, "And now the plane is in its last resting place." He had certainly never imagined it would wind up on display at the Smithsonian.

In 1936, Dennis R. Smith visited the Smithsonian and saw the plane hanging in a place of honor alongside the *Spirit of St. Louis*. He met Martin on the street in Canton one day and told him about the display. "Mr. Martin, then an old man of 81, with long white whiskers," wrote Heald, "and gentle and quiet spoken in manner, had the happiest moment of his life when he knew that his contributions to air pioneering had been memorialized by the preservation of his machine." Martin had been an admirer of Charles Lindbergh and had corresponded with him over the years. He must have been thrilled to know that his glider, humbly constructed in his Canton barn, had achieved such great notoriety. The label on display with the plane read:

> MARTIN GLIDER. Made in 1908 by William H. Martin, Canton, Ohio, based on his aeronautical experiments begun in 1887. Last flown [publicly] in 1909 at the old Morris Park Race Track, New York City.
>
> It was launched like a kite, rising about 50 feet, being towed by a horse or automobile. The pilot, usually Mr. Martin, sat on the boards between the wheels and operated the direction and altitude controls. Lateral balance was inherent due to the use of sloping surfaces, known as "dihedral." The length of the flights was about 250 feet, being limited by the size of the field.
>
> In this machine several members of Mr. Martin's family made flights, including Mrs. Almina Martin (his wife) and Miss Blanche Martin, then 8 years old. As many as 25 trips were made in one afternoon.
>
> Gift of William H. Martin

Around the time of this donation, Martin was quoted in a local paper expounding on the future of aviation: "I believe now that there is a new era started in flying machines but that it is going to become a great deal safer and machines will be built so that they cannot go into a nose dive or tailspin and they will not be a constant care." He predicted planes of the future would be much easier to fly than contemporary planes: "There will be no need for the handling of controls so much. The machines will fly much more steadily. If the control is not touched, the engine will go at a given speed and run indefinitely holding its course."

Martin had many models of planes in his home and workshop, including the "devices" he used to make his glider. In a 1931 newspaper account, writer Kerwin Tanuay reported that Martin's models included "every detail of the device incorporated in his first flying plane and the tiny crafts will right themselves in mid-air regardless of the position in which they are launched." It is not known what became of these items. The article also noted that Martin's V-shaped balancing plane design has "since been applied to perfect the monoplane."

Martin died in March 1937, in the home he had lived in for 44 years. He was laid to rest at Warstler Cemetery. His obituary highlighted his wife's devotion to his passion for flight: "Mrs. Martin, his widow, was the constant inspiration for his aviation work and always accompanied him on his trips. She also made arrangements for his participation in various flying meets." In a *Repository* article a few days after his death, Almina said, "It has been a long

time, but I will never forget the thrill of those flights. It was just like floating on air, and I felt as safe riding through the air as I do now in my rocking chair. My husband undoubtedly discovered principles far in advance of his day." Almina died on December 8, 1944.

Many years later, the Stark County Historical Society (today known as the Wm. McKinley Presidential Library & Museum) sought to bring the glider back home to Canton. Initial inquiries were rather disturbing to local museum officials. No one at the Smithsonian seemed to recall a contraption known as the "Martin Glider." As *The Repository* reported on August 19, 1979, "Since World War II, part of Canton's role in aviation history lay in pieces of wood and rotting fabric, 'lost' in one of the forgotten storerooms of Washington's Smithsonian Institute." Things often change in museum exhibitions, and "permanent" displays are removed in favor of new acquisitions. Such was the case with the Martin Glider.

Local museum officials persisted, and eventually the "lost" plane was found. It took over seven years to cut through the bureaucratic red tape, but the Stark County Historical Society was finally permitted to borrow the glider. It was shipped back to Canton, essentially in shambles. "What we got from the Smithsonian was a box of sticks and three wheels," said Rod Lang, who worked for SCHS. "It was a matter of laying sticks side by side and saying this one looks like it goes here."

The museum spent more than $7,500 restoring it. In a letter to Walter J. Boyne, Curator of Aeronautics at the National Air & Space Museum, dated September 6, 1978, Gervis Brady, then director of SCHS, writes, "You will be pleased to know that there are no parts missing. Some few, being so badly broken, had to be replaced or repaired." In 1993, long after his retirement, Brady recalled that "the late Henry Hoover loaned us space in a huge barn on the Hoover North Canton farm and Paul Marks agreed to work on it." The pieces had been numbered, but were apparently not accurate, which added considerable frustration to their reconstruction efforts. In all, it took 18 months to fully reassemble the Martin Glider and prepare it for display.

On October 25, 1976, in the midst of negotiations with the Smithsonian for the return of the glider, William H. Martin II wrote to Brady to inform him of his plan to build a replica of the glider, and to start a movement to get his locally famous grandfather on a postage stamp. He wrote about Martin's connections with several famous aviators of his time, some of whom even came to Canton to meet with Martin. "Mr. Brady, I can tell you this much," he wrote, "if our departed friends Harry Renkert and Howard Hughes were alive they would applaud what we are doing. I'm sure you are aware that

Harry first introduced me to Howard who came by to see my grandparents. Harry brought Howard to our home. . . . I have been searching for copies of letters between my grandparents and Lindy. So far I have not been able to locate any. On at least one occasion Harry Renkert, Howard Hughes and Lindy got together with my grandparents in our home on Harrisburg Rd. to talk design of aeroplanes and flying in general. This was pryor [*sic*] Harry giving me my first lessons in powered aircraft. The enthusiasm of this group was highly contagious." Hughes also reportedly came to Canton in 1937 to pay his respects after Martin's death.

Eventually the Smithsonian transferred ownership of the glider to the Stark County Historical Society and it was added to the permanent collection. The reassembled Martin Glider hung in the Museum's science wing for many years, until plans for Discover World revamped the entire space. Again the plane was taken apart and placed in storage. In 2002, the Military Aircraft Preservation Society (MAPS) approached the Wm. McKinley Presidential Library & Museum about borrowing the glider to display in one of their hangars adjacent to the Akron Canton Regional Airport.

On a cold fall Saturday, staff members from both museums met to move the glider to its new home on long-term loan to MAPS. Although it was calm, as they carried the wing to the waiting moving truck, a gentle breeze found its way underneath it and threatened to send it soaring! Clearly Martin's painstakingly designed glider wanted to be airborne that day, even if it was disassembled. A team of MAPS volunteers reconstructed the glider, replacing parts that had inevitably deteriorated while it was in storage, and placed it on display in 2005. The glider that once captivated Canton's attention a century ago continues to fascinate us today.

Just a few years after Martin's wife Almina became the first woman to fly a "heavier-than-air machine," another young Canton woman was about to make history herself when she signed up for flight lessons in New York City. Almina never had the chance to pilot anything with an engine, but Bernetta Miller would soar through the clouds at speeds far greater than a farm horse could run.

5. A Man Can Fly, so Why Can't I?
Bernetta Miller, Early Bird

Canton has gained national fame for many individuals who have lived here, including William McKinley, "Boss" Hoover, H. H. Timken, and countless others. But sometimes the people who make history don't wind up in our textbooks. They are extraordinary individuals who live ordinary lives. It is through the study of local history that we can bring these characters to life, and tell their stories. Bernetta Miller is one of those people.

Born in Canton on January 11, 1884, Miller was the daughter of Cassius M. Miller and Mary Hale Adams. Her father attended Candandaigua Academy in Canandaigua, New York, and had a passion for inventions. He obtained over 200 patents in his lifetime and created many machines, one of which he donated to the Farmers' Museum in Cooperstown, New York. Years later, Bernetta traveled to see it. "I went up there once to see a model of my father's," she said. "It had not been unpacked. They said if they had known I was coming, they would have had it unpacked. I sure would like to see it and hope to sometime. When I think of all my father was and did, I am most proud. A self made man. My mother too was a wonderful woman." Her mother attended the Ontario Female Seminary. Both of her parents were far better educated than most Americans at that time.

Miller grew up on Lawrence Avenue NW. She later moved to the Lomgabaugh Building on North Market and became one of William McKinley's neighbors. Toward the end of her life, she corresponded with *Repository* writer Helen Carringer in preparation for a local feature story about her. In one letter, she recalled her parents' interaction with the McKinleys:

> My father who was active in politics on the side as 'twere knew him [McKinley] well. My mother, I think must have known Mrs. McKinley sometime previous to 1891 as she wrote her up for the *Ladies Home Journal*. (I still have the clipping which Mr. Bok himself sent to me when I wrote and asked about it.) At that time McKinley was in state politics I think and he was in the limelight on account of a McKinley tariff bill which he introduced.

Miller was only 12 years old when McKinley ran his famous Front Porch Campaign from his home on North Market. She recalled standing on the street outside his house with some girlfriends, chanting "Hurrah for McKinley, he's the man. We can't vote for him, but our daddies can!" In a letter dated January 11, 1963, to George Putnam, she recalled the excitement of the Front Porch Campaign in 1896:

> I failed [in my last letter] to mention anything about President McKinley whom we all loved and used to see frequently. (I never sat on his lap tho as Gretchen [Putnam] did.) At the time of his inauguration and until after his election I lived in the Lomgabaugh Bld. on North Market St. We had a bay window and used to see all of the many delegations which arrived with bands and floats to greet McKinley. . . . The day of his inauguration . . . we had planned to go to our Lawrence Avenue house to pick cherries. We had been told that when we heard a cannon shot, it would mean he had been inaugurated. We heard it all right and immediately started homeward down North Market Street past the McKinley home. Canton, in those days was a soft coal city. And were we grimy! When we returned to the Groetzinger home, Mrs. G. was surely annoyed with our filthy condition. It was one of the few times I ever saw her really annoyed.

Miller had many other fond memories of her hometown, including the old Aultman Home on North Market. "I can still see old Mrs. Aultman sitting in the window," she said. "I used to love to climb up on the stone ledge at the edge of the pavement. The Aultmans and the Harters were someone in my day."

In 1904, Miller enrolled at the State Normal School at Geneseo, which is today part of the State University of New York system. During her sophomore year, her father's business failed, and she felt she needed to return home. But instead of giving up her dream of a college education, she entered the Canton Actual Business College, where she earned a diploma in bookkeeping. The college was one of the leading business educational institutes in northeast Ohio at the time, and had a reputation for producing successful employees. Founded in 1876, the Canton Actual Business College trained thousands of men and women for a variety of office positions, offering courses in shorthand, typewriting, bookkeeping, accounting, spelling, penmanship,

and business administration, with practical training on various office machines and appliances. Shortly after graduation, Miller moved to New York and found employment as a bookkeeper, earning $5 a week.

She was a life-long learner, taking college courses whenever and wherever she could, mostly in English. "I took what I liked," she said. "I wasn't trying to get a degree. It wouldn't have done me any good in my work." She took classes at Columbia in New York, studied at Cornell University, and spent one summer at the University of Vienna.

Later, as strange as it may sound, Miller would tell reporters she was bored in New York City. But at the time, women's options for activities and entertainment were extremely limited. One can imagine a young lady so far from home, spending most of her days working in an office, faced with long, lonely evenings when she returned to her apartment.

She began saving money from her meager paycheck to take flight lessons, which were not cheap. "It cost me plenty," she said, "as I did not have my father's support. In fact, he knew nothing about it until my name appeared in the papers." At the time, aviation was in its infancy, and only a handful of women had even attempted to get a pilot's license. When asked why she decided to take lessons, Miller replied, "Partly adventure, partly boredom with office work and also the desire to make money."

She signed with the Moisant Aviation School in Mineola, Long Island. The Moisant brothers operated one of the few schools that would teach women how to fly. At a time when most people were hailing the biplane as the standard aviation design, the Moisants used monoplanes, which had only one wing.

"To obtain a license in those days was not complicated," Miller said. "We did not have all the gadgets they have now." There was no teacher beside her, and no double controls. In the December 2, 1928, issue of *The World Magazine*, she wrote, "If I were to state it in one sentence, I'd say we learned by conquering fear and leaving the rest to luck. That is all it was."

The students were not tested for physical or mental ability. According to Miller, the school was chiefly concerned with being paid. First a licensed pilot gave them theoretical training, mostly "in what wasn't known about gyroscopic force, angles of incidence in relation to flying, and other allied uncertainties," she said. Then the student got into the cockpit of the plane, with its motor running, to get used to its sound. "When we had had numerous turns in the stationary airplane," she said, "trying theoretically to sense how it feels to fly, trying to absorb what had been taught us, the uses of different parts and getting acquainted with the unwieldy skeleton-like

bird, we were then taken out on the field at sunrise and initiated into what was technically known as 'grass cutting.' This was merely learning to run the airplane in a straight line over a fairly smooth course."

While it sounds simple, "grass cutting" was extremely difficult for Miller to grasp. She said it was far easier for her to take off and land than it was to keep the plane moving in a straight line on land. And it was a bumpy ride. "Every slight bump was accentuated in the machine tenfold," she said. This initial training could make or break a student's courage. "I have seen the nerves of trapeze performers and rough chauffeurs, as well as millionaires' pampered sons virtually snap under this preliminary training, which would appear a most simple matter."

Grass cutting was also quite dangerous. "I never saw any one killed during this process of learning," she said, "but I have seen many 'near killings.' And I came more nearly meeting my death in this grass cutting stage of learning than I ever did flying thousands of feet in the air or in landing."

There were many things that could go wrong when first learning to fly, and a mechanic's carelessness only added to the risk of Miller's early lessons. When she was just beginning her lessons, a chief construction mechanic was working on the plane and had whittled away part of the block that kept the aircraft from flying. When she began her grass cutting lesson:

> I was amazed, as were the onlookers, to have the machine shoot in the air! Things happen rapidly even in a 35 horse power motor driven airplane, and I tried to do some quick thinking, not then being a willing or learned flyer. I was headed for bad land, telephone poles and wires. So, as I could not turn, I did the simplest thing by shutting off the switch. I landed with a thud and cracked the motor . . . Everybody started running to my rescue, dead or alive. As usual, I remained unhurt, and was only concerned for the damage to the machine, which I was thankful had not been my responsibility.

After mastering grass cutting, students were allowed to make short hops with the plane, gradually making the hops longer and longer until they could be considered a "flight" of five or ten feet. "It was a very important period in the learning," she said, "and was hard on the machine as well as the student. . . . One gradually learned to sense the feel of flying and to realize that much of it is done by feel, just as one steers a motor boat, except that in a motor boat the wind does not play the part that it does in a heavier-than-

air machine." The "hops" off the ground were always done in a straight line. Next the students learned to turn.

A woman pilot was such an unusual thing to behold, the media naturally followed her every move. Stories about her appeared in newspapers across the country, usually focusing on why a woman wanted to fly. In the *Fort Wayne Sentinel* on October 2, 1912, Miller said, "A man can fly, so why can't I?" The story quotes Lt. Gustave Salinas saying, "Aeroplaning is no work for women—it's only meant for men. As a man and as an aviator, I ask you not to go up into the air." Apparently, Miller laughed at him, turned on her machine, and started into the air, saying, "I think you've made a mistake, Lieutenant. I am going to earn a pilot's license this afternoon. I'll show you that women can ride the air as well as men!" Whether or not this exchange actually took place, it accurately expresses Miller's opinion about female pilots. She was a pioneer, and she knew it.

The test itself was relatively simple. The pilot had to take off and land in one piece, perform ten figure-eights around markers, reach an altitude of 1,500 feet, and land within 150 feet of a previously designated spot. "To take the flight for the license meant that we were permitted to use the best airplanes available in the school at that time," she said, "which in my case was a monoplane of the Bleriot type equipped with a 50 horse power Gnome motor. I can hear the purr of that motor today and feel the thrill it gave me as it answered the controls so readily. With it under my command, I knew the license was as good as won."

Miller made her solo flight on September 25, 1912. "It was a beautiful evening," she recalled. "As I rose the required 1500 feet over the heart of Long Island I could see the ocean on one side and the Sound, which looked like a mere ribbon, on the other. Then I descended a little lower to make the ten required figure 8s around the flags which were held by officials of and witnesses for the Aero Club." The U.S. government did not issue pilot's licenses at the time. Instead, the Aero Club of America issued them, under the auspices of the International Aeronautical Federation headquartered in France.

The figure-eights Miller performed were rather large, but there was no size requirement as long as you went around the flags. "I was erring perhaps on the side of caution," she said, "but evening and mists were fast approaching. I could see the flashes from the lighthouses near the Navesink Highlands, and it was becoming difficult to distinguish the markers. By the time I was ready to land I could not see the landing marker at all and had to fly over the spot several times. Those on the ground finally realized my difficulty and raised the white sheet, so that the landing was made in proper order."

Officials measured the distance of her landing, and took the sealed barograph that measured altitude. "Then, in a few days, the little leather booklet reached me." She was the 173rd person, and only the fifth woman, to earn a pilot's license in the United States. She was just 22 years old.

When asked how she could "exhibit such nerve" when she flew, Miller answered, "Well, I just figure it out this way. You can die only once, and when your time comes to die nothing can save you. And until your time does come, nothing can make you die. So why should I fear?" Media reports claimed she was better at the controls than Harriet Quimby, the first woman to earn her pilot's license, claiming Bernetta "often landed in the very tracks made by her machine in its ascent."

After she received her license, the Moisants were asked to demonstrate their monoplanes for the federal government. Bernetta Miller was chosen to test pilot the plane. She was under no delusions as to why she was selected for this honor. "The Moisants apparently calculated that I could overcome some of the fears that others might have of the monoplane. I suppose that this was on the basis of the idea that if a mere woman could learn to fly one, so surely could a man. The Bleriot monoplane which I flew was considered dangerous and tricky by those who had done flying. They apparently thought two sets of wings were safer than one."

It is difficult to imagine the infancy of flight in an age when we have sent a robot to the surface of Mars. But in those days, aviation was still a "fringe" activity, with few supporters. Miller recalled the skepticism of the era:

> Most people in the autumn of 1912 could not believe that flying would ever be practical. A few grudgingly accepted Wilbur and Orville Wright and Glenn Hammond Curtiss. Only the pusher-type biplane was fashionable then, beginning from the time when the pilot sat out in front (and not strapped in!) with nothing but air between him and the earth. If anything went wrong, as it often did, the aviator was the casualty. . . . There were also, at that time, those who could not see beyond the idea of the dirigible.

In 1912, Miller arrived at College Park, Maryland, the site suggested by Frank P. Lahm three years earlier to train the first military pilots, the day after a horrific airplane accident. The mood was somber after the death of one of the Army Air Force's most promising young pilots. Miller recalled their lack of enthusiasm, saying, "it was bad enough to shovel up a man;

they did not welcome the idea of having to shovel up a woman." Harold Kantner, another Moisant pilot, came to College Park with Miller. She described him as a careful pilot, who "made it clear to me that he did not approve of women flying." She said it was unfortunate that they were paired together, because he was a year ahead of her in flying and was much better, and yet the media gave her all the attention. It made for an uncomfortable situation for both of them.

In the midst of negative feelings about female aviators, Miller began her demonstration flights. She did not like the landing field at College Park, comparing it unfavorably to the site in Mineola where she had trained:

> At College Park, there were woods on one side of the bumpy field, train tracks and telephone poles and wires on the other. There was no nearby emergency landing spot, other than swampy earth with stumps of trees still standing, but these were not visible from the air. These obstacles were big hazards in 1912 when aircraft were fragile and their engines uncertain.

Miller stayed at College Park for a week, and could not recall how many flights she had made. She kept no log book. She remembered she had been taught to land her plane with the power full on, but the Army Air Force pilots cut off their power. "We couldn't regulate it then," she said:

> Our wing loadings were probably never more than three of four pounds to the square foot, and we knew nothing of aerodynamics. I was told to try a landing with what today we call a "dead stick." A briefing might have helped. Until then, I had never made a bad landing. I had muffed other aspects of learning to fly. I was not prepared for the sensation of gliding through the air without power. It was eerie and the wind whistling through the wires was uncanny. It was a bumpy landing—on bicycle tires.

While Bernetta Miller was at College Park, Orville Wright was there to investigate the cause of the accident that had killed the pilot the day before her arrival. On the day she was scheduled to meet him, a pilot went up in a rebuilt Wright biplane and was stunting with it when he was supposed to be giving it a test flight. "A madder man I had never seen as he made a rush from the field," she said. "It was no time for introductions."

During her stay, a large Votes for Women suffragist parade was scheduled in nearby Washington, D.C. Mrs. Glenna Tinnin, an organizer of the event, had sent Miller a telegram asking her to fly over the parade with a "Votes for Women" banner trailing behind her plane. What better way to energize their cause than a woman flying a plane over a suffragist parade? It was the perfect punch the women needed to get their point across.

Although Miller had not yet responded to the invitation, the media picked up on the event. An article soon appeared in *The Evening Standard* in Ogden City, Utah, saying, "In order to demonstrate in spectacular manner the advancement of women, the managers of the suffragist parade here March 3 have invited Miss Bernetta Miller, a woman aviator, to swoop down into Pennsylvania Avenue in her aeroplane on that day with a message for 'Miss Columbia,' the central figure in tableaux which will be staged on the steps of the treasury department building." Some news accounts even confirmed her appearance.

Despite the publicity, Miller declined, saying she was afraid of getting lost high above the ground in unfamiliar territory. "I was not afraid of making the flight," she said, "but I was afraid of losing my bearings. Geography has such a way of changing when one is in the air. No doubt I could find the Capitol and Pennsylvania Avenue, but how about finding College Park or any good landing spot? I was too inexperienced then, a fledgling, in fact." But in retrospect, she always wished she had made the historic flight.

Although she declined to fly over the parade and make history, she planned to leave her mark in another way. On January 20, 1913, Bernetta Miller attempted to establish a new altitude record for female aviators. As she soared high into the sky, her oil flow indicator broke, spewing oil into her face and eyes. The novelty of a female pilot who cheated death was definitely newsworthy. The *Racine Journal-News* described the scene: "She is the most prominent woman aviator in this country at the present time, and recently she gave a wonderful exhibition of her nerve and skill by bringing her biplane safely to the ground after an oil cup on the engine had burst and blinded her with hot oil and bits of glass." *The Coshocton Tribune* in Coschocton, Ohio, ran the following ad for a "double feature" newsreel on February 22, 1913:

<div align="center">

At The Mystic Today

SEE

Bernetta Miller, the only American aviatress who

descended safely after an explosion blinded

</div>

her 1800 feet in the air
Fierce fighting between wolves and trained dogs
Latest pictures of the Balkan War
3 Big Reels
Five Cents American Money

But Miller did not become a pilot for the fame. She wasn't out to prove anything, champion her sex, or become a role model. She simply wanted to fly.

Soon, however, she started to become disenchanted with flight. She had never wanted to become a circus flyer, performing dazzling feats high above an audience. She had hoped for a career in commercial aviation, which was simply not possible for a woman in the 1910s. Plus she was quickly mounting up debt from her "hobby." Decades later she told a reporter, "I just couldn't afford the luxury. With my living expenses, I was involved up to $5000. I cancelled an insurance policy and used all the money I had in the bank, but I paid off every penny. There seemed to be no future in aviation then. We were all thought to be fools."

As violence erupted in Europe, Miller joined the Women's Overseas Service League in 1914 and was sent to France. First she served as an accountant, because of her background in bookkeeping. But she soon realized there were plenty of people qualified for that kind of work, so she asked for a transfer to someplace where she could help more. She was assigned to the 326th Infantry Regiment of the famous 82nd Division. She became a canteen worker at the front, serving food, coffee, and doughnuts to soldiers. The canteens helped to boost the morale of the troops by providing musical performances, an opportunity to write letters home, and giving the men a place to relax for a few moments in the midst of fierce fighting.

Miller worked hard to bring some comfort to the wounded soldiers she came into contact with:

> I wouldn't want to say I had a rough time at the front, because it was the men who had a rough time. There were men who had been lying in the field for several days. The division asked us if we would help. There were two other girls and myself. One memory I shall never forget. Anything we did for a man under those circumstances—and many of them probably died within 24 hours—he invariably said "thank you" or "God bless you." It didn't matter whether you told them not to talk or to rest.

For her war work, Miller received the prestigious Croix de Guerre from the French government, and many American citations as well.

After the war, she came home and tried her hand as a cub reporter at the *New York Free Press* for awhile. Then she traveled to Istanbul, Turkey where she became the bursar at the American College for Girls. She enjoyed her work there immensely, and spoke of her experiences often. "In those days, it was nothing to walk 20 miles a day," she said. "We had the Asiatic shores nearby. We would go there and sit in the coffee houses." It was in Turkey that Miller developed her passion for Oriental rugs, becoming an avid collector. She stayed there from 1926 to 1933, when a new administration took over the college. "They had a change of presidents and I didn't like him, so I left. It was a foolish thing to do in the midst of the Depression."

But as usual, Miller landed on her feet. She found employment as the bursar of St. Mary's Hall in Burlington, New Jersey, in the middle of the academic year in 1933. Mrs. Ruth (Herbert) Bird worked with Miller for four years at St. Mary's. "Miss Miller was an individual!" Bird wrote about her in a 1983 letter to Paul Garber, curator of the Smithsonian's National Air & Space Museum:

> In appearance she was tall, with rather a small head for her height; her hair short—I can't recall whether its curliness was natural or permanented. She might have been called "plain" except for her smiling, friendly manner. . . . She let it be known that she had been Bursar of the American College in Constantinople [now Istanbul] for seven years. . . . She said she had tried free-lance writing in New York City, but the tight times made it impossible for her to sell her work. Her savings became depleted.

Although Miller had learned to fly a plane 25 years earlier, she had never gotten a driver's license. "Within a couple of months, Miss Miller went downtown in Burlington and bought a used car," Bird recalled. "She let us know that she had never driven. She took just a couple of lessons, then got in and drove—to the alarm and astonishment of the rest of us. I can still see her driving away from the school steps, around the circle and out through the great wrought-iron gates, hunched over the wheel, gripping it tightly, her face intent."

Bird also enlightened the Smithsonian curator about the origin of Miller's extensive Oriental rug collection:

She said that after the novelty of her Constantinople life wore off, she found herself on the brink of boredom, and someone told her she must find a hobby—something constructive that she could really become wrapped up in. So she not only made herself a collector and connoisseur of antique Orientals, she invested heavily in them. She had been given the room directly over her office in the 1823 building which formed the heart of St. Mary's, and had lined it with rugs: on the floor, on the walls, over tables. One day I found Miss Miller out on the sloping tin roof over a first-floor sun porch *shampooing* rugs. St. Mary's suffered a fire, one Sunday afternoon a year or so later. Students and faculty all reacted perfectly as they had been drilled, and the city's fire department kept the damage to a fairly small amount. When it was all over, I walked out on the little used "front porch" of the old building, overlooking the Delaware River, and there stood Miss Miller with a rug rolled up under her arm.

Many years later, Miller sold one of her rugs to the Philadelphia Museum of Art. According to Bird, after her death, the museum was asked to purchase all of the collection, but did not have the funds to acquire them all. It is unclear what became of the rest of them.

In those days, Miller seldom mentioned her aviation career to her co-workers. Bird recalled an incident where a student stopped her after lunch and asked if Miss Miller had ever piloted a plane. "Heavens, no!" was her quick response. The young lady's mother had taught at the American College with Miller and had taken her to a reunion in New York City. When her mother introduced her to one of the men in the group, he asked where she went to school. Upon answering St. Mary's, the man said, "Let's see. Isn't that where Bernetta Miller is?" He went on to say that she had been a pilot.

Bird searched for a tactful way to pose such a question and asked the student not to tell anyone else. She waited until the right moment came along to speak to Miller:

Not very long after, Miss Miller invited me, along with two of my closest friends among the faculty, to tea in her room. We sipped tea, discussing and admiring the many lovely oriental objects around us. I asked which rug she had "saved" the day

of the fire. "That one," she laughed, "and it is not the most valuable." Then I fired my shot. "Miss Miller," I said, "I am going to ask you a question you may not want to answer. Did you ever pilot a plane?" My friends were dumb-struck. Miss Miller's face grew expressionless and she looked off at the wall. Then she relaxed, and very slightly nodded her head. . . . Then we talked freely. Miss Miller said, "There have been two occasions when I thought my secret was out. The *Ladies Home Journal* published a story about women in aviation and mentioned my name; and when I told people about never having driven a car I remarked that I had driven every other kind of engine. But no one mentioned either thing." "Don't you miss it?" I said. "Wasn't it exciting?" "Not really," Miss Miller answered. "It's lots more fun to do stunts in a Chris-craft!"

It is unclear why Miller felt she had to hide her aviation experience during this period of her life. Perhaps she was tired of talking about it, constantly explaining why a woman would want to fly, and why she stopped abruptly so many years earlier. Maybe she feared people would laugh at her, or see her as some kind of oddity. Later in life, she was far more open about her flying, and was very proud of her aviation past.

In 1941, Miller left St. Mary's to take a position as Dr. Frank Aydelotte's assistant at the Institute for Advanced Studies at Princeton University. While at the Institute, she worked with Albert Einstein, whom she called "a dear," adding, "We all protected him and tried to screen his calls and visitors. Of all the men at the Institute, he was one of the kindest. He had a different assistant every year. One of them walked back and forth to the Institute with Einstein. I asked him what they talked about and the assistant replied, 'He gives me a new problem every day.' He loved everybody. He was the nicest, most outgoing man. There was nothing petty about him." Erica Mosner, a library assistant at the Institute, confirmed that Miller knew Einstein, saying, "the Institute is a fairly intimate place even today, and must have been especially so at that time. Professor Einstein would surely have had regular dealings with the Institute's Director's Office, and therefore one can imagine him at least exchanging pleasantries with Miss Miller on those occasions." Mosner also noted that Miller had an assistant of her own, which would have indicated a high level of responsibility in her position.

Miller remained at the Institute until 1947, when she left to become the head resident of Colby College in Waterville, Maine. Carolyn Caci was a

student at Colby during this time, and Miller was her housemother for two years. She described her as extremely laid back, but not irresponsible. She was always in control of a situation. Caci and the other girls would listen to her stories about flying and serving in World War I for hours. "She was riding right into the front lines," Caci said. "She was right where people were being killed. During World War I it was unheard of that a woman would be anywhere near combat. She was my mother's age, and people my mother's age just didn't do that. They got married and had kids. We would sit there with our mouths open. She wanted to be an inspiration to us. She wanted us to be adventurous, that was her message: don't settle for less than you are capable of doing. She was ahead of her time."

Caci recalled Miller's apartment being full of those beautiful Oriental rugs she cherished so much. The girls were welcome to join her in the sitting room, which Caci recalled had a "very cozy, homey atmosphere," but her bedroom was strictly off limits. She was very open, but also cherished her privacy. "She was so accessible, and so easy to talk to," said Caci. "She would answer any questions I had. She had a wonderful sense of humor. We laughed a lot. Talking to her, my stress would float away."

In those days, college dining was extremely formal. Caci worked in the dining hall as an evening waitress. "I waited on the head table every night," she said, "serving three unmarried ladies. We served them from the left, moving to the right. It was very nicely done, and we had to be on our best behavior."

During this period, Miller's eyesight began to fail, which is why she shifted from accounting work to residential hall supervision. Reading tiny numbers in columns became too much of a challenge for her. But it did not stop her from driving her car, as Caci recalled: "I rode with her just once, and I was never so scared in my life! She had no peripheral vision, so she had to turn her whole body."

Miller left Colby in 1955 and went to work at Wilson College in Chambersburg, Pennsylvania. She retired in 1962 and moved to the small town of New Hope, Pennsylvania, on the Delaware River just north of Philadelphia. She continued to attend reunions of her World War I regiment, as well as receptions for those who had worked at the American College in Istanbul. In an interview with *Repository* writer Helen Carringer, she admitted she would not fly in a jet. "That's a terrible thing for a pioneer to say. I would fly in a prop plane, but I don't fly in any old plane or with any old flier. I think a lot of accidents can be traced to carelessness and cocksureness." In a letter to Carringer a few days later, she clarified her comments. "What I

said about jets may cause considerable criticism. I simply feel that when emergencies arise, that the pilot does not have time to think. It was risky enough in the old days. You know that even when driving a car, there are times when you've got to do quick thinking even though you may not be going faster than 60 miles."

In 1963, Miller was honored as a member of the Early Birds, made up of 565 daring pioneer aviators who made a solo flight before December 17, 1916. In 1930, Cy Caldwell described an Early Bird as "one of that fraternity of pilots who flew during the first decade of practical flight. He's the chap who flew the pre-war vintage aeroplane when the present generation of pilots were toddling about in bib and romper; he's the bird who sat on the front edge of an open work box-kite and dared the thing to take him off the ground." And so Miller joined the prestigious ranks of Orville and Wilbur Wright, Frank P. Lahm, and Glenn Curtiss. Only a handful of women made the list. She said herself of the Early Birds, "Being honored as an early pilot surely was never anticipated. In those early days people in general considered that we were rather wacky." Miller donated her Early Bird plaque to the Stark County Historical Society (today the Wm. McKinley Presidential Library & Museum), as well as her original pilot's license. She tried to attend as many Early Bird reunions as she could.

Bernetta Miller died on November 30, 1972, at her home in New Hope. She was 88 years old. A few days before her death, she had broken her hip. Because of her frail condition, doctors could not operate. Her obituary appeared in the *New York Times*, an honor not bestowed upon many. She was laid to rest at West Lawn Cemetery in Canton, sharing a stone with her parents and her brother who was killed in action in France during World War I.

In Bernetta Miller's time, early "barnstormers" took off and landed wherever they could, in farmer's fields, clearings in the forest, or grassy strips that passed as runways at newly created airfields. Communities across the country were just beginning to develop local aviation centers, and Canton had several that sprung to life with the new age of flight.

6. Any Sane Person Took a Train
Canton's Early Airfields

In the early days of aviation, thousands of tiny airstrips and airfields existed in communities across the nation, operated by local aviation enthusiasts. Some developed into major airports. Others have faded into memory, now the sites of housing developments and shopping centers. As in many cities, none of Canton's original airfields exist today, but the memory of those early pilots still lives on.

One of the best known local pilots was Leon D. Sherrick, who was born on January 13, 1896, to Alwyn B. and Josephine Sherrick. His uncle was Johnson Sherrick of Aero Club fame. He attended West North Grammar School and Central High School in Canton. He spent three years at the Case School of Applied Sciences in Cleveland and one year at the University of Washington in Seattle.

Sherrick learned to fly in 1915 with "Pop" Blakeslee at the Curtiss Factory in Buffalo, New York. He enlisted in the Signal Corps Reserves in 1917 and was sent to Urban, Illinois, where he worked as a flight instructor. He was discharged as a second lieutenant on January 9, 1919. He joined the Canadian Air Service at Camp Borden, where he served as an instructor for a short time. In 1919 he opened Sherrick Flying Field at the site of the old Meyers farm on Broad Avenue NW and 17th Street. His plane was the first to be based in Canton.

After receiving his commercial transport license, Sherrick operated a successful passenger plane service. He owned five planes, charging $25 for a "fancy trip," including loops and spins, and $15 for a "straight flight." As more pilots came onto the scene, and competition increased, the prices per flight plummeted to $1 or $2. He barnstormed the country, performing daring aerial stunts in his plane. In those days, planes were made of wood and bailing wire, with "a little cloth draped over them," as early pilots recalled.

In 1920 he started the Sherrick Flyers, where he taught pilots to do stunts. To attract spectators, many students started walking on the wings. A hat was passed through the crowd, and according to *Repository* writer Lester McCrea, "The young daredevils would pick up a nice piece of change some Sunday afternoons." Some of those "young daredevils" included Bernie Cade, Earl "Red"

Miller, Paul Wines, and Homer Miller, who later became Sherrick's sidekick in aerial stunt shows. Miller was a cabinet maker who once replaced the cable wires on one of Sherrick's planes. When Sherrick expressed concerns about the strength of the repairs, Miller agreed to go up with him on a test flight. "I protested," Sherrick said, "but Homer climbed out on a wing while we were in the air and shook the plane to prove everything was OK. The newspapers heard about it and they wanted a picture. And that started our stunting career."

As described by McCrea, a typical routine would "start off with him standing on his head on the top wing; standing on the top wing directly in back of the motor while the plane did a loop-the-loop, with the centrifugal force holding him on; a series of stunts on a trapeze suspended below the lower wing; a dive off the end of the wing with only a long rope attached to the ankle [known as the "swing of death"]; and finally a parachute drop to earth." Homer Miller performed death-defying tricks like these high above spectators, becoming well-known all over northern Ohio. Miller claimed to be the first one to stand on the wing while the plane performed a loop-the-loop. He once broke three ribs when the plane he was riding pulled out at the bottom of the loop, and the force was so great it knocked him down.

In what would be their final appearance, Miller and Sherrick went to Cleveland to appear with the Kindred Flying Circus on August 31, 1924. Miller was to transfer over a rope ladder from the top of Sherrick's plane to one flying just above him, but the planes were too close together. The propeller of the top plane cut a deep gash into Miller's back, seriously injuring him. He fell unconscious, but luckily his foot became tangled in a wire strut. Sherrick landed with him still on the wing. His wife had been told he wouldn't live three months. He survived, but his stunt flying abruptly came to an end. His back was severely scarred, and he was plagued with problems stemming from the accident. Thirty-six years later he was hospitalized for surgery brought about by the original injury. After he stopped stunting, Miller went on to become the area's first government-licensed airplane mechanic.

Both Miller and Sherrick had brothers who were killed in aviation-related activities. Raymond "Bud" Sherrick was performing aerial stunts during an air show at Lake Milton, near Youngstown, in 1925. As his plane reached the top of a loop, it failed to come out of it. His plane landed upside down in the nearby woods and he was killed. Earl "Red" Miller had set a world record in the 1920s for an altitude jump above the Akron Municipal Airport from a height of 20,400 feet. It took him 45 minutes to descend. He was killed on September 15, 1930, when his head struck a rock after a 2,000 foot parachute jump, far shorter than his world record jump. He had jumped 300 times.

Paul Wines retired from stunt flying in 1926 and became one of Sherrick's pilots. In 1929 he came out of retirement to do his routine at an American Legion sponsored air show at the airfield on Harrisburg Road. He bought all new equipment for the occasion, including a new trapeze. One week after the show, he set up the trapeze in the basement for his daughter to play on. The very first time she used it, she came crashing to the ground. Her mere 40 pounds had broken the very piece of equipment her father had been perilously dangling from seven days earlier. "I spent several sleepless nights thinking of that," Wines said.

In 1926, Sherrick went to Miami, Florida, to perform with some other stunt flyers. The stunter was supposed to climb up a rope ladder from a speedboat, but when he grabbed onto the ladder, it was wet from dipping into the water. It wrapped around his wrists, tangling him and preventing him from climbing up the rest of the ladder. Sherrick recalled the incident to Lester McCrea in 1953:

> I remember looking at him down there. Several times I came down low and tried to wash him off in the water but it was no use. I must have had him down there about a half hour. The last time I dragged him through the water the force tore his trousers and I thought he was injured. It came time that I had to do something with him so finally I went over and landed him on the sandy beach and he suffered only a few scratches.

Sherrick was indeed a skilled pilot to perform such a perilous landing. He had to be careful that the tail of the plane didn't come down and crush the man.

Over his career, Sherrick had several forced landings, although none were serious. He flew when pilots actually had to fly "by the seat of their pants," said *Repository* writer Frank J. Laston. Many of the navigation instruments today's pilots take for granted had not yet been invented.

Sherrick's aviation activities included some other, more mainstream kinds of flying as well. He worked for the Stout Airline Company, ferrying passengers from Cleveland to Detroit. "In those days I saw absolutely no passenger future for the airlines," he said. "It was too expensive and too uncomfortable . . . I had 26 passengers on a plane and 26 of them were airsick, and I could see no reason for people to go through that. However, they started making planes bigger and flying them higher and I was wrong in my prediction." Sherrick himself was never sick in a plane, but could not ride in the backseat of a car.

Sherrick became one of the best-known pilots east of the Mississippi. He once flew Canton photographer O. N. Peck, who took some of the earliest aerial views of the city. A contemporary account of the trip said, "Considerable danger was braved in taking some of the pictures for the photographer and the pilot flew unusually low in the business and closely-built up resident sections in order to get the best possible photographs." Sherrick also taught many area residents how to fly at his flight school, including Mac McFarland, Morris Koehler, Joe Schiering, Amos Lichty, F. L. Nape, Sam Ross, and Perry Lloyd. Weather permitting, students were allowed to practice taking off and landing. When the weather was bad, they studied ground courses in things like motor repair and air currents. He once said, "Flying as a hobby has become a business, and there are times for work as well as play."

As early as 1928, Sherrick began clamoring for an airport for Canton. In an article that appeared in the *Canton Daily News* on June 3, 1928, Sherrick said, "Aviation is the coming method of transportation and it already has proved its worth by the present development being extended through the airmail service and other commercial express and passenger lines. And if Canton wants to keep up with the times the establishment of a properly managed airport is necessary."

In 1930, Sherrick became a pilot for the Timken Company, flying a Ford Tri-Motor. He took the Timken plane to many races and competitions. In 1931 he won first place in a speed race for Ford Tri-Motors at the National Air Races in Cleveland.

In May 1942, Sherrick started his second tour of service in World War II. He then became base operations officer at Orlando, Florida, with the Army Air Corps. He tested planes and worked out tactical problems of attack and defense. He left the service October 28, 1945, with the rank of major, having flown every type of plane the Army had except jets. Sherrick lived at Lake Cable, spending the winters in Orlando. He died in March 1965 at the age of 69. He was a member of the Quiet Birdmen, and had flown over 11,000 hours in his lifetime.

Claude Nelson Hart was another early pilot in Canton. Born near Anderson, Missouri, in 1894, Hart went overseas with the aerial squadron during World War I. He was a machine gunner and observer and learned how to fly while in the Army. After the war, he took a job with the railroad in Alliance and was later transferred to Canton, where he bought a home on Mahoning Road NE.

Hart wanted to make Canton a center for commercial aviation. He rented farmland from the Pontius farm, off Mahoning Road where a shopping center was later constructed. He built a wooden hangar and started flying biplanes, just two miles from the center of town. Together with V. J. "Goldie" Goldsmith, Hart started Canton Aero Taxi and Advertising Company in the early 1920s. In 1926, the company's name was changed to the Canton Aero Transportation Company. Local department store Stern & Mann was the first company to fly merchandise into Canton via the Canton Aero Transportation Company.

Hart opened a flying school, offering courses in advanced aviation, theory of flight, navigation meteorology, motor and plane building and repairing, structure and rigging, cross country flying, and air commerce law. His flight lessons were based on the Rankin System of Flying Instruction, used by over 60 flying schools nationwide at the time. Pioneer John G. "Tex" Rankin developed a series of booklets that covered all aspects of flight, emphasizing safety as a priority.

In the late 1920s, Hart leased 175 acres for ten years from Otis Clay, creating the McKinley Airport. The facility became popular, offering gas, oil, and repair services for other pilots. Among the many improvements, Hart constructed fire proof hangars with sleeping compartments, lights for night flying, a rotating beacon light that was visible for 40 miles, and a ceiling projector to determine the height of the clouds. With equipment for night flying installed, Hart began advertising "moonlight rides" over the city. Hart also sponsored parachuting exhibitions and air shows, one of which had 50 airplanes in the air at once! By 1928, Hart offered commercial and passenger flights across the country, and daily sightseeing trips over Canton.

In 1929, the Canton Aero Transportation Company was reorganized into McKinley Aero Ways Inc. and later the McKinley Air Transport Company. After spending years trying to get the city to back the project, Hart sold his interest in the business, although he kept a private plane there for many years. In 1933, the McKinley Air Transportation Company took over McKinley Field, and from then on the two names were used almost interchangeably until the company moved to the Akron-Canton Regional Airport and the airfield was shut down. Earl Kail and U. A. Whittaker took over operations.

According to a 1945 airport directory, McKinley Airfield had four sod runways, the longest at 3,200 feet, and two hangars. During the war years, George Swayze managed the facility until Kenneth A. Little and Andy Marks bought the entire operation in 1948. Timken had built a large steel

hangar at McKinley Field in 1930 to house the company's Ford Tri-Motor. The partners purchased the unheated hangar and ran McKinley Air out of that facility for a few years.

Marks had started flying in 1928, with Lee Sherrick as his flight instructor. He remembered flying at the Akron-Canton Airport before it opened. "We'd fly up about 2 or 3 in the morning and chase the deer off the runway." Little was a World War II pilot who had learned to fly in 1939 at the old McKinley Airport. He went there for the first time to buy a car from Kail. He signed up for a commercial pilot's course instead. After Pearl Harbor, he went to Florida and became an instructor at the Air Corps training center. Later, he trained 750 pilots and assisted 750 more. In his lifetime, he logged over 20,000 hours of flight time. He flew for the military ferry command and spent 700 hours carrying cargo and personnel over "The Hump" between India and China. He wanted to be a commercial pilot, but at 5' 6" he was six inches short of the height requirement. In 1948 he returned to Canton and purchased McKinley Air Transport with Andy Marks. He became the sole owner in 1958.

McKinley Airport was a small operation. "There were actually five runways," Little said. "But you had to know they were there. Runways were just lots you mowed." In the beginning, very few businessmen flew. "Any sane person took a train," Little joked. In those early days, business was indeed sporadic. "Business might survive the summer and fail in winter," he said. His wife Helene remembered the early days too, saying, "There was more than once when Kenny started we'd be out there at 10 o'clock at night, pushing planes." They couldn't afford a truck, and they couldn't pay too many people to help.

Republic Steel was located south of McKinley Airport, and Little remembered the benefit of having the plant close by. "Back when we were flying low horse power planes, you'd circle over Republic Steel to get a lift to get up in the air." Thermal pockets from the plant heated the air and gave the planes an extra boost.

The "airport" at McKinley Field was really not much more than the McKinley Air Transport office and a hangar at Mahoning Road and Harmont Avenue NE. Henry Timken's and Roy Poorman's hangars were up the road on Harmont, and Malloy's Service Station and restaurant was nearby on Mahoning Road. Despite the limited space, pilots gathered at McKinley Airport anywhere they could. It was a friendly, informal atmosphere. Pilots who weren't even flying out that day would stop by to spend time with their buddies. The clientele was often unique as well. Little remembered gospel groups showing up at McKinley in the middle of a tour of revival tent

shows. They would pay for fuel in "nickels, dimes and quarters from metal dinner plates they used for collections," he said.

The old airfields, and the early aircraft they housed, held a certain mystique that has all but disappeared today. Little once said, "There's something about the sound of rain on a fabric wing that's like rain on a tin roof. It draws you. You don't accomplish much, but it's fascinating." These small airfields are missed by many who long for a simpler time. "There's something pure about a small airfield," said Terry DeMio in a 1998 article that appeared in *The Repository*. "Something uncluttered and simple. No rushing, no fussing. Clean air and not a single control tower to poke the fresh blue sky. No public address drone of scheduled and delayed flights—just the sput-sput-buzz of a turned prop, the roar of a takeoff, the bump of a landing. And then quiet."

McKinley Air Transport served many functions for the aviation community. The company operated a flight training school, charter air service, hangars, and some maintenance and radio repair. After moving to the Akron-Canton Airport, McKinley Air refueled all of the commercial airlines, which equaled one million gallons a month in the early 1980s.

Before the development of Akron-Canton, McKinley Airport was considered the "official" airport of the city. Little recalled that the facilities at Martin Field were a little better than at McKinley, but transportation into the city was difficult. "A bus line went right past our door," he said. City council designated specific locations for marking the area to assist planes trying to land at McKinley, as stipulated by state and federal regulations. A. R. McConnell, secretary of the Canton Automobile Club, told City Council, "I was told by the state director of aeronautics that Canton would have to get busy and do something at once about an adequate landing field for ships [as airplanes were often called]. It is necessary that something be done to protect the airmen who are traveling in this locality." In compliance, city council decided to paint "Canton" on the roofs of the Auditorium, the grandstand at the Stark County Fairgrounds, and the Timken plant. An arrow on top of the Auditorium pointed toward McKinley Airport and a light on top of George D. Harter Bank in downtown Canton was used as a beacon. The federal regulations stated that when a revolving light was used as an aid for night flying, a beam of light must point to a landing field.

In 1950, McKinley Air Transport was given a 30-day notice to move because the property they leased had been sold to a developer. While it must have been quite a shock for Little and Marks, the eviction was actually good for business. McKinley Air disassembled its original 10,000-square-

foot hangar and moved to the new Akron-Canton Airport, a much larger facility that had the potential for growth.

As the aviation industry grew, McKinley Air grew right along with it. They provided every service a commercial airline or private pilot could want. By the time Little sold it in 1978, it had grown to 40 employees and 12 planes.

In the midst of an ongoing recession in the 1980s, McKinley Air made the conscious decision to try to expand. In 1982, Bob Dexter, vice president of McKinley Air, said, "You always have to strive to make something happen. You can't sit back and wait for things to happen, because they won't. And if they do, they aren't going to be things you like." The company bought a 30,000-square-foot hangar at Akron-Canton from Firestone, which more than doubled their space.

McKinley Air has always been aware of the special needs of its customers. Throughout the company's history, its pilots have had to fly at the spur of the moment, sometimes between scheduled charter flights. They also store and maintain corporate and privately owned aircraft. In 1982, the company began expanding its "landlord" role at the airport, cutting back on some of its own services in order to lease hangar space to existing companies that could provide more specialized services. This arrangement was more economical for the company, and actually provided a wider range of services. For example, space was leased to a company that repairs flight instrumentation, which had not been offered at Akron-Canton for many years. Prior to reviving that service, a specialist had to be summoned from Cleveland.

The air traffic controllers' strike hit McKinley Air hard. Decreased flights meant fewer fuel sales. Dexter was sure things would turn around once the strike ended. "Once the traffic gets here, there are all kinds of business it can generate," he said. "But it has to get here first."

By 1997, McKinley Air was thriving. Known as a "fixed base operator," it catered to the needs of companies and individuals with private aircraft. In the early days, airplanes were simple, single-engine contraptions with basic mechanical needs. As aviation developed, planes became more sophisticated and demanded a wider array of services. McKinley Air President Don Armen wanted his facility to be the finest in the nation. Renovations began that would improve the look and feel of McKinley Air, as well as the services the company offered.

Akron-Canton Airport Director Frederick Krum said McKinley Air was special. "It's one of the nicest fixed base operations I've seen," he said. "Usually, you would have to go to Atlanta or Dallas to see something as nice."

The newly renovated facility included two 12,000-square-foot hangars with 26-foot-high doors to accommodate Gulfstreams, Falcon 900s, and other tall jets. The hangars featured bright, easy to clean tiles from Summitville Tile. "We have the first hangars with tile floors that I know of in the United States," Armen said. The initial cost for the flooring was higher, but maintenance over time would be cheaper.

McKinley Air could now house up to 25 aircraft, compared to just 15 in the old hangar. Owners prefer indoor storage to keep their planes out of snow and to reduce the need for de-icing. The new 10,000-square-foot passenger terminal offered visitors a plush waiting area with comfortable furniture and waiting areas, workstations for the pilots and crew, private showers, private suites for visiting dignitaries, an executive board room, and leasable office space. Armen wanted something that was upscale, yet functional, that would continue to attract customers from around the world. "We wanted to make a statement," he said. "This tells visitors that we're a first-class, growth area." Krum agrees. "For a lot of very important people, this is the first thing that they see," he said. "When business people, celebrities, or government officials come through, McKinley is where they get their first impression of the community."

Customers at McKinley Air have included the NEC World Series of Golf jets, corporate executives, and dignitaries from many different countries. Celebrities have also used the facility, including Donald Trump, John Travolta, Bob Hope, Julio Iglesias, Don Johnson, and Hillary Clinton. Several key business meetings have taken place there. IBM and Diebold met to work out the details of the joint venture Interbold. Bridgestone and Firestone representatives held acquisition talks there. "Some businesses prefer to meet here because it is a neutral site," Armen said.

Claude Nelson Hart would probably never recognize what his humble Canton Aero Taxi Company has evolved into. From a small operation located on a grass runway to a modern, state-of-the-art aviation support facility, many changes have taken place over the years.

Another early pilot was Harry Renkert, a native of Canton who learned to fly at Roosevelt Field in Garden City, Long Island. He earned his private pilot's license in 1927 and his commercial license the following year. In 1929 he returned to Canton and started the Canton Air Service Company at McKinley Field with partner Eddie Gerber. In 1931, Gerber left the business.

Renkert, whose family operated the Metropolitan Brick Company in Canton, wanted to own an airport. In the 1930s he purchased 100 acres in the northeast section of Canton, next to William H. Martin's farm, and moved his company there. It later became known as Martin Field.

In 1938, Roy Poorman moved Poorman Aircraft Service from McKinley Field to Martin Field, further expanding the facility. Poorman was born December 16, 1907, on a farm near Navarre. As a young man, he had worked on farm tractors, cars, and stationary gas engines. He began flying in 1923, barnstorming and hauling passengers wherever he could. "We went from one town to another," Poorman said, "wherever there were people." From 1928 to 1930 he operated a flight school and charter service at Riceland Airport in Orrville. From 1930 to 1937 he ran the Wooster Airport, then started his own aircraft repair service.

Poorman received 25 patents for various inventions over the years. His company manufactured many parts for military transport planes and machine guns, as well as parts that helped to protect planes from heat-seeking missiles. He also built parts for F84 and F100 jet fighters. In the 1960s, Poorman's company made parts for spacecraft, including solid magnesium instrument panels and parts of guidance systems for lunar landers. In fact, some of those guidance systems were left on the moon by Apollo astronauts deliberately and are still there to this day. According to *Repository* writer Gary Brown, parts of Roy Poorman's craftsmanship are tucked away in all kinds of obscure places: "Tiny metal items made at Martin Airport remain stuffed in tubes in nuclear reactors, plugging the faulty cylinders and keeping citizens all over the country safe from radioactive fluid that once flowed inside." This was incredibly precise work. "They had to be accurate to one-fiftieth of the thickness of a hair," Poorman said. "That isn't very much." He had so many inventions in his lifetime, Poorman said, "I've got a stack of patents this high [roughly knee height]. I've sold most of them."

His business grew to four buildings at Martin Field during World War II, as he shifted his focus to wartime production. "For the machine gun, we made the head spacing nut, the buffer sleeve, the buffer piston, the firing pin, the ejector," Poorman said. "We made a lot of parts for that gun." Poorman's company also produced cables for drag chutes that slowed planes down when they landed and winches to tow planes from field to hangar. In 1972, his company incorporated as Poorman Aircraft Inc., and became a Piper dealership. He sold the business in 1978. He won many awards from the Department of Transportation and Federal Aviation Administration.

In addition to Poorman's business, Martin Field was also the home of the Stark County Aero Club, formed by local pilots in 1945. The group sponsored air shows and car raffles. Over 5,000 people attended the third annual show and race on September 19, 1948. Highlights of the show included a demonstration of formation flying by the Akron Naval Air

Reserve Squadron and a glider demonstration by Russ Hissom of Zanesville. Dusty Rhodes gave a parachute show, Cook Cleland did aerobatics in his Corsair, and a race took place from Martin Field to East Liverpool, around Magnolia, and back to Martin Field.

In 1949, pilot Joe Green of Massillon kept his planes at Martin Field. Green co-owned a five seat twin engine Cessna and had a BT-13 Army trainer of his own that he used for sky writing. On October 2, 1949, he was interviewed by *The Repository* about his skywriting business. That day he had written the name of a local department store over Canton in letters that were nearly a mile long, and three miles high in the sky. He had also been hired by political campaigns and commercial firms for his services.

To be readable from the ground, Green had to make the letters upside down and backwards. He would make up a chart ahead of time and carefully follow it while he was in the air. If he made a mistake, such as an extra vertical line on a capital "E," he wasn't able to tell until he landed. Skywriting is done on a horizontal plane, so the pilot can't get enough perspective to see what he is writing until he ascends or descends to another altitude.

Curves were done with one stroke, but it took several strokes to create letters like "E" and "H." He had to make the cross bars of the letters at a slightly higher altitude so the prop wash, or air currents created as the plane flies, did not disturb the lines he had already made. A five letter word was usually stretched out five or six miles. Each letter was about three-quarters of a mile wide, separated by an eighth- to a quarter-mile in between. The words were so big, Green once started one over Massillon and by the time he was finished he was over Alliance.

To perform skywriting, a pilot needed a clear day. Too much wind would break up the letters before the pilot was finished writing the whole word. Wind also moves the letters, causing the pilot to chase them across the sky. Most skywriting was done at an altitude of 15,000 feet, where the air is a little calmer. The higher the lettering, the more visible it is to a larger area of people. If the weather was just right, Green said people in New Philadelphia and Akron could see his work over Canton.

Green needed special equipment for skywriting, including a 30 gallon drum, which was placed where a rear seat had formerly been. An engine-driven fuel pump routed chemically-treated oil through the exhaust pipe, with a valve controlling the emission. About one gallon of oil was used for each letter, which cost $10 a piece.

Renkert sold Martin Field to Thomas Warren Miller of Akron in 1955. In return, Renkert purchased Al Capone's palatial Miami Beach estate from

Miller. The "magnificent stucco home"—with a red tile roof, 16 rooms, and 7 bathrooms—had been purchased by Capone in 1928. The home had attracted great crowds of tourists since the gangster's death in 1947. It was surrounded by a high concrete wall and boasted the largest indoor swimming pool in Dade County. It reportedly was furnished with costly French furniture, huge crystal chandeliers, and expensive Chinese rugs. Renkert also owned a private yacht in Florida and operated a shrimp boat.

Renkert's interest in civilian aircraft waned as he turned his attention toward military planes and other hobbies. Miller continued offering parachute jumping and instruction, flight lessons, and plane rides at Martin Field. It became the last large privately owned airport in Canton.

Martin Field originally had four sod runways, two of which were later abandoned. The airfield was closed and re-opened several times over the years. In the 1960s, it was apparently known as the "Canton City Airport" on flight charts. In the 1980s, the owners were listed as "Canton Air Sports," which was described as a parachuting operation. Martin Field was closed for good in 1997.

Small airfields have struggled to stay open in recent decades. Most privately owned airports have been re-designated as "landing fields," which have restricted their use and sometimes the services they can provide, including selling fuel. It has become increasingly expensive to operate a small airfield. Aviation today is a major industry, far different from the airfields of yesterday.

Local aviator Jim Keller thinks it is a shame that so many small airfields have been lost. "Increased operation costs and insurance, among other things, have caused a lot of fields to re-think operations or close all together," he said. "It's terrible. Having more small airports means more convenience for those of us who fly." He put the loss of these airfields into perspective for non-pilots: What if, for example, our government said the maintenance of our roads cost too much, so they would only maintain 90 percent of them? What if the road to your favorite grocery store was suddenly closed, or not plowed in the winter? Or worse yet, the street you live on? Sure, there would be ways to get around that, but overall, running errands would be much less convenient. But Keller acknowledged small airfields are not without their challenges. Most are impassable in the winter from snow and soft ground. So even though the overhead might be less than at larger airports, revenue always fluctuates seasonally.

Even in those early days of flight when airfields were almost as common as parking lots are today, a local company played an important role in the manufacture of airplane parts. The Timken Company, well-known for its contributions in the automotive business, also has a rich history in aviation.

7. REACHING NEW HEIGHTS
The Timken Company

Canton's contribution to aviation may not be readily apparent every time a passenger boards an aircraft, but almost every plane flown today is equipped with some type of component or system made by the Timken Company. Although the company is most widely recognized for its roller bearings, Timken has also supplied the aircraft industry with "Super Steel," seamless steel tubing, and miniature bearings for precision applications.

According to Bettye H. Pruitt, author of *Timken: From Missouri to Mars—A Century of Leadership in Manufacturing*, the Timken tapered roller bearing is a "critical part of the landing gear of most of the world's commercial aircraft, as well as the space shuttle, and an integral component of the designs for the next generation of military aircraft and quieter commercial jet engines." Timken steel and super precision bearings can even be found on the Mars Pathfinder spaceship. "The Mars mission," says Pruitt, "arguably the most electrifying event in the U.S. space program since the first walk on the moon in 1969, is symbolic not only of what technology has achieved but of the next phase of space exploration and the new technological challenges on the horizon."

Timken's most significant connection to aviation began decades before the Mars mission, when metallurgist Martin Fleischmann developed a new high strength alloy steel that would perform well at high temperatures, allowing planes to fly at higher altitudes. Fleishmann came to Timken in 1928 and began working with students at the University of Michigan the following year. According to Pruitt, this unique partnership was relatively inexpensive and helped to establish long-term research and development during the Depression years. Once the economy recovered, Fleischmann and his team had developed several products that would open new markets and generate more revenue for the company.

Fleischmann arrived at Timken to find a small research staff and very basic facilities. "You could count the people on the fingers of one hand," he said. "There was a microscope but nobody knew how to run it. And they gave me a corner up there in the bearing factory fenced in with chicken wire and that was my laboratory. That was it!" In 1929 Timken built a suitable

metallurgical lab for him, located next to the steel mill on Harrison Avenue. During the worst of the Depression, staff cuts forced Fleischmann to work without an assistant for several years.

The new facility featured all the bells and whistles the scientist would need to develop cutting edge products. According to Pruitt, there were experimental furnaces for alloying and heat treatment, equipment for studying the problems of gas and inclusions in molten metal, and an elaborate device for determining corrosion resistance of different alloy compositions under varying conditions.

In 1931, Fleischmann's first invention was the corrosion-resistant alloy nickel-chromium-molybdenum, which was developed as a steel that could perform well in high-temperature environments. This new material helped lay the groundwork for the development of a related alloy called 16-25-6, better known as Super Steel, which could withstand the intense heat inside turbocharged engines flying at high altitudes. Super Steel would prove its immense value during World War II, allowing Allied planes to fly well beyond the reach of German anti-aircraft gunfire. Allied planes could fly deep into enemy territory on bombing missions without worrying about being shot down from the ground, a significant tactical advantage. After the war, 16-25-6 would be used to develop turbojet engines, and Martin Fleischmann would earn a worldwide reputation for his invention.

Fleischmann had been a German aviator in World War I. His experience in flight provided him with the inspiration for developing his new steel alloy. He had served as a pilot for observation flights in France, and his plane had depended on altitude for safety. He could soar to 18,000 feet, which was beyond the reach of French, British, and American anti-aircraft fire at the time. He never forgot the "inherent advantages of high altitude flying."

After World War I ended, Fleischmann enrolled in the University of Munich to study mechanical engineering. Metallurgy was a relatively new field at the time, which fascinated the young scientist. He decided to specialize in it and after graduation stayed on at the university as an assistant professor of metallography. Over the course of time, Fleischmann became discouraged with the German economy. Inflation was out of control. Completely disgusted with German politics, Fleischmann emigrated to the United States in 1924.

He arrived in New York with $50 in his pocket, not knowing a soul. He only knew enough English to mispronounce it, which created a significant language barrier. Unable to communicate effectively, the former science professor from a renowned German university became a truck driver's

assistant. He moved from job to job, finally finding employment with a large Pittsburgh steel company. Soon after, he came to Canton.

Timken published a press release with the title "Scientist Invents New Steel to Boost U.S. Airplane Ceiling!" to announce to the world Fleischmann's new invention. "Three years ago American aircraft engineers realized that if a special, tough, heat-resistant steel for a vital part of the turbo-supercharger could be developed, it would add thousands of feet to American aircraft ceilings," it said. "Fleischmann, remembering the security he enjoyed as a pilot of the German high altitude observation plane, went to work at once to provide the necessary steel."

His success was touted as an amazing American achievement, born of a German mind that would outperform his former countrymen. The press release went on to say "altitudes are so great that German fighter planes cannot rise above American planes now rapidly becoming equipped with superchargers made from the ex-German aviator's steel. . . . It is paying tremendous dividends in the lives saved and planes that come back to fight again over the empires dominated by Germany and Japan."

Super Steel was a significant contribution to wartime aviation, but other Timken products, particularly the roller bearing, also played a part in the airplane industry. Even before the war, in order to continue to expand, Timken had to find new markets for products that already existed. The commercial aircraft industry was the latest and greatest thing for passenger travel, and Timken got involved from the beginning. "With a long established record of economy and improved standards in automobile and rail travel," one ad said, "Timken Bearings are establishing themselves in the newest field of transportation—Aviation." Timken bearings used in aircraft and tail wheels meant quicker take-off, greater wheel rigidity, less wheel drag, uniform brake action, longer tire life, less ground looping, better maneuverability, simplified lubrication, and less maintenance. A 1943 advertisement described the early applications of Timken bearings: "Even before the barnstorming era of aviation Timken Roller Bearings were extensively used in plane landing and tail wheels."

Other ads also highlighted the uses of Timken bearings in aircraft applications. The crankshaft had to be rigid enough to withstand shock loads caused by explosion pressures and to keep proper alignment at all times. The rocker arms were subjected to rapid successions of shocks and continuous vibration during the operation of the engine. These problems could be solved through Timken bearings. Reducing friction on landing wheels with Timken bearings would allow planes to take off faster, allowing

them to use airfields with shorter runways. In addition, Timken bearings could handle the heavy shock, thrust, and radial loads caused by the force of the landing, as well as traveling down the uneven surfaces of early airfields. One advertisement explained, "The clearance between the brake and drum is very small, and must be accurately maintained. Otherwise the brake action would become erratic, enough so, that the plane might get out of control."

According to an article reprinted in 1930 from *Aviation Engineering*, the increased size and weight of airplanes meant increased stress for the landing gear and airplane wheels. Anti-friction bearings would help to increase performance of the new planes, with primary requirements of strength, durability, and lightness. When flying, there is no weight at all on the landing gear of a plane, although it is subjected to continuous vibrations and extreme temperature fluctuations from the altitude. Upon landing, there is a sudden and dramatic impact on the landing gear. Tail wheels proved to perform better than skids. They protected the surface of the flying field better, increased the maneuverability of the aircraft, and eliminated some of the stress to the fuselage. This innovation provided yet another new market for Timken bearings. The *Aviation Engineering* article stated:

> Experience has shown that anti-friction bearings have added considerably to the performance characteristics of airplane wheels, both landing and tail. They have increased the safety factor, because they do not wear and cause brakes to bind, or wheels to wobble. They improve the ground acceleration of ships [airplanes], thus rendering them more practical for use on restricted fields, and have made them much easier to handle on the ground or in the hangar, either manually, or under power. And, last but not least the lubrication problem both economical and practical is greatly simplified; the expense and care required to keep the wheels lubricated properly is greatly reduced.

Timken continued on a path in aviation that was quite similar to its contributions to the fledgling automotive industry a few decades earlier. Timken bearings became standard in almost every type of aircraft from the beginning. "Practically every up-to-date aeroplane engine," said W. J. Chievitz, field research engineer, "from the Wright Whirlwind as used by Lindbergh on his flight to Europe, down to the small two cylinder engines, is equipped with anti-friction bearings, not only on the crankshaft but often on the other revolving shafts and even rocker arms." He added that

it was significant that the wheels of the Ford Tri-Motor have used Timken bearings "as standard equipment since its inception." Timken bearings had an excellent service record in the Tri-Motor, as a maintenance worker testified, "Before we put the Timken bearings in the plane's rocker arms, we had to check and lubricate them before every flight. However, with Timken bearings, that problem was eliminated entirely and we never had any trouble at all." Although the Tri-Motor was short-lived, Timken bearings were used in several other types of aircraft.

During World War II, Timken continued to produce other parts essential to the war effort, including bearings for all kinds of aircraft, tanks, destroyers, and submarines and seamless steel tubing for gun barrels and other uses. The amphibious tank carriers used in the Normandy invasion in 1944 were also equipped with Timken bearings. During the war years, Timken produced over 300,000 supercharger wheels. Timken also made many aircraft engine parts, such as piston pins, propeller hubs, and crankshaft bearings. The new high-temperature alloys also had an auxiliary use in the production of synthetic rubber and high-octane gasoline for aircraft, since steel used in oil refineries was subjected to temperatures up to 1,500 degrees. As is often the case during wartime, products were developed on extremely short notice, and Timken worked nonstop to develop and produce new bearing products that would support the war effort.

The sheer volume of parts required for a single vehicle or aircraft during the war was astounding. A four-engine bomber used 162 Timken bearings, a medium sized tank used 72, a large tank used 100, a scout car used 30, and an anti-aircraft gun used 28. In 1943, bearing production had more than doubled pre-war rates. Significantly, the average bearing produced for the war effort was 60 percent heavier too, because larger war machines required larger parts. The huge Bendix landing wheels, for example, were each 96 inches in diameter.

The loads these bearings could handle were also astounding. The two-wheel landing on a Bell Aircobra produced a vertical load of 19,665 pounds per wheel, a drag load of 6,777 pounds, and a side load of 4,376 pounds. The Bendix wheels had two bearings per wheel, each required to carry a load of two tons.

Timken bearings were also found in the gearbox and drum shaft of bomb lifting mechanisms inside bombers. The stakes were high. A bearing failure in this application could result in a bad miss or total destruction of the aircraft. A wartime ad boasted, "Timken bearings are used in all military and commercial aircraft, and in most small private planes." If

the automotive industry provided the first mass market for anti-friction bearings, the World War II aviation industry created the second greatest stimulus for ball and roller bearing applications. During the war, Timken produced half a million rocker arm bearings, plus an additional 250,000 bearings for engines, every month.

Government and military officials recognized the significance of bearing production to the war effort, using it to advantage in winning the war. Allied air forces specifically targeted German bearing plants as a top priority, in addition to oil production and aircraft facilities. If you could take out the bearing factories, you could virtually paralyze your enemy.

Even during the war, Timken was planning for the transition to a peacetime economy. One wartime advertisement read, "Look ahead! After defense, the greatest opportunity in airplane history. Make the most of it with new designs using Timken Bearings throughout." Other ads built on the same theme: "Aviation is a grim business today—a business of bombs and bullets. Its greatest opportunity will come after victory; then cargoes of commerce will replace loads of destruction. Then Timken Bearings will help to keep 'em flying for prosperity." Indeed, commercial planes had already successfully used Timken bearings for decades. In 1944, Robert F. Six, president of Continental Air Lines Inc., said, "On part of Continental's routes the distances between stops are quite short—we average a take-off and landing for every 38 minutes of flying time. As a result, landing gear equipment on Continental planes is subjected to severe service and the various landing gear parts, such as bearings, must be of the highest quality."

Super Steel and bearings were not the only wartime aviation innovation. Seamless steel tubing, developed primarily for gun barrels, was also used for propeller blades. As one advertisement put it, "War loads of men and material are heavier in the faster, bigger planes made possible by one-piece propeller blades made from Timken Seamless Steel Tubing." Propellers needed to be larger, but they couldn't be too much heavier and increase the overall weight of the plane. Hollow steel instead of solid aluminum provided the answer.

After the war, Timken continued to play a role in military aircraft production. An article in the August 1945 issue of the *Timken Trading Post* announced that the new Army Air Force helicopter Kellett XR-8 was equipped with 20 Timken bearings, in the nose wheel, main wheels, top and bottom of the clutch shaft, upper and lower first pinion shaft, and the second pinion shaft. After the Air Force became its own branch of the military, a Timken advertisement announced that North American's F-86 Sabre Jet

used Timken bearings on the nose and main landing wheels. "The main wheels roll with the punch on Timken tapered roller bearings. . . . Wear and maintenance costs are cut, life extended. Under normal conditions they will last the life of the wheels."

Timken stainless steel also found its way into aviation applications. In an ad titled "Kitchen in the Clouds," the company proclaimed, "A delightful dinner, a speedy trip, and a safe landing—Timken Stainless Steel in the kitchen; Timken Alloy Steels in many vital parts of the fuselage, wings and power unit; Timken Bearings in landing wheels, rocker arms and Timken Alloy Steel in landing gears." The ad went on to explain that Timken was the leading source of aircraft steel because it had the largest facility in the world for "producing steel that readily meets the rigid aircraft specifications."

While aviation business soared, a few Timken employees made headlines in the company newsletter for their activities related to the Experimental Aircraft Association. Harold Startcher and H. P. "Bud" Whittaker each built a homemade airplane in 1960 as part of the 12 member Canton chapter of the EAA. Founded in 1953, the organization was devoted to encouraging home-built sport and racing aircraft and boasted 9,000 members worldwide at the time. Home-built aircraft became popular after World War I when crated surplus planes were sold to former fliers, who assembled and flew them for sport. The newsletter article noted that nearly all home-built planes were equipped with Timken bearings in the wheels.

The men picked out their plane plans and hoped to be in the air by the summer of 1961. Startcher chose the Nesmith "Cougar," a 19-foot two-seater plane with a wingspan of 20 feet, 1 inch. It would be equipped with an 85 horsepower engine and have a cruising speed of 150 miles per hour. Whittaker chose the EAA Biplane, with a single seat, open cockpit design. It was 16 and a half feet long, with a wingspan of 20 feet and a maximum speed of 108 miles per hour. Nearly all members of the club were model plane enthusiasts, and most claimed it was not necessary to have a technical background to build a plane. They said the reasonably priced plans were easy to follow. Construction costs were expected to be $1,000, while a similar plane produced by a professional airplane builder would cost six times as much. Members did not have to build their own plane, but everyone had to be an active member of a team that was building some kind of plane. There was a "club ship" being produced by several members of the club. Startcher and Whittaker pooled their efforts, sharing the talents each possessed to help the other one's project. Startcher was a welder, and Whittaker was proficient in the wood shop. Whittaker had earned his pilot's license in 1946 and was

part of the occupation forces in Japan after World War II. Startcher was taking flying lessons at the same time he was building his plane.

Timken also has a rich history of corporate and private plane ownership. As a student at Harvard at the age of 21, H. H. Timken Jr. had earned his pilot's license, igniting a lifelong love for aviation. In the late 1920s, he personally owned a Ford Tri-Motor, which was a great plane, according to his chief mechanic C. L. Patton:

> It was very forgiving of any errors and very dependable. It was the best way to travel at the time. We couldn't travel in bad weather and we had to be very careful in any weather that was ahead but if conditions were good, we could land just about anywhere and make pretty good time. . . . We had no such radio equipment as they have today. We only had one radio, which gave us weather reports, an altimeter and some engine gauges. The best navigation facility we had was when the most popular path flights were lit from the ground so we could follow them. Other than that, we really didn't have anything to help us.

When Patton retired, the Timken family presented him with the steering wheel from the plane he had spent so many years working on. In those days, lines were blurred between personal and corporate aircraft, since the planes were flown both by Timken himself and an employed pilot, Lee Sherrick, who flew planes for Timken until World War II.

In the late 1940s, Timken hired Craig Schull to pilot a surplus Cessna UC78. Soon after, the company purchased a Lockheed C60 twin-engine utility transport aircraft. They were not happy with the performance of the UC78, so it was replaced with a D18 "Twin Beech," the fifth of its kind to be manufactured. Schull resigned in 1950, and copilot George Dippel became the corporate pilot.

In 1951, the company purchased its second D18 Twin Beech. In the spring of 1953, the company acquired a North American B25 Bomber, which had been converted to an executive plane by Continental Oil Company. The Twin Beech planes were sold in 1953 and 1955.

In 1957, H. H. Timken Jr. purchased a twin-engine jet from a French manufacturer, the first privately owned civilian jet in the country. The plane was a Morane-Saulnier 760 Paris, with a wingspan of 33 feet. It was capable of traveling at 350 miles per hour. The 5,600-foot runway at Akron-Canton Airport was more than enough to accommodate it, because the four-seater

plane only needed 3,000 feet to take off. H. H.'s wife Louise also flew the plane, becoming the first woman to be qualified to fly jets.

Timken said his new plane was not a company plane, but for his own personal and business use. He purchased it through Beech Aircraft Corporation in Wichita, Kansas. He had flown a Morane-Saulnier 760 Paris a few years before in Youngstown when the firm had the plane on tour. He had been impressed with it and decided to purchase the jet for himself. The "Twin Beech" that he had previously owned could only go as fast as 185 miles per hour. The new jet flew nearly double that speed.

H. H. transitioned into the jet age in the early 1960s. He ordered a 500-mile-per-hour Rockwell Jet Commander for the company, and a Lear Jet 23 for himself. The B25 was sold in December 1964, and the Jet Commander arrived on January 12, 1965. In October 1972, the company purchased a Sabreliner 40A, once again owning two aircraft. The Jet Commander was traded for a quiet, long-range, fuel efficient Sabreliner 65 in July 1980. The Sabreliner 40 was sold and replaced by a Cessna Citation II in 1981. Company pilot Dippel retired in 1983, after more than 30 years of service. John B. "Jack" Yarger became chief pilot and was later named manager of aviation services. He retired in November 1987 and David Settle took over. In January 1986, during tough economic times, the company was forced to sell the Cessna.

Timken's corporate aviation program operated throughout its history without a single accident. The company insisted that safety be a number one priority, and they only purchased high quality equipment and employed top level aviation personnel.

Aviation, while not a major aspect of the company's production, has always played some kind of role in Timken innovation. In recent years, the company has acquired several other aviation-related companies, creating a matrix of diversified production that has found its way into many applications. In 1990, Timken purchased the MPB Corporation, a leading producer of precision ball bearings for the aircraft and aerospace industries. Timken was looking to expand into that market, which made the opportunity particularly attractive. Miniature bearings were the brainchild of Long Island inventor Winslow S. Pierce Jr. in 1936. Legend has it that Pierce had a special silver pocket watch that had a cracked jewel and he could not find any jeweler with tools to repair his watch, so he went back to his shop and created a miniature bearing to fix it himself.

These tiny bearings became an integral part of precision applications for companies like Bell & Howell, Eastman Kodak, and General Electric in

products such as compasses, gauges, chronometers, and other instruments. After the 1957 launch of Sputnik, the miniature bearing industry suddenly found a brand new market in the fledgling aerospace industry. Timken's acquisition of MPB in the late 1980s marked its entry into the space flight industry, which was a natural extension of its involvement in the commercial and military aircraft markets.

In the past decade, Timken has expanded into the aerospace market by making several acquisitions and investments in its aerospace capabilities. While Timken still supplies bearings for the same or similar airplane uses as it did in the early days, the company has expanded beyond bearings and steel to provide customers with aerospace bearing inspection and repair, aircraft engine overhaul services, and a more extensive product offering including gearboxes and other related systems. According to J. Ron Menning, vice president for aerospace, consumer and super precision, Timken intends to "expand our aerospace portfolio by making strategic investments that help us improve customers' performance." Typical customers include commercial and military aircraft operators, government space programs such as NASA, and providers of helicopter transport for industries such as offshore drilling and emergency services.

Timken has made many significant contributions to the aviation industry, ranging from landing gear and Super Steel to precision applications in the space program. In addition to H. H. Timken's personal interest in aviation, he was also intricately involved in the development of the Akron-Canton Regional Airport, the area's first modern aviation center. He and his wife Louise both served on the airport's board. After his death, Robert Luntz, president of the Luntz Corporation, said Timken was "an inspiration, not a stunt man or a barnstormer, but a practical man who savored each moment in the air. Akron-Canton Airport was his second home. . . . In the early 1930s when people pooh-poohed aviation, he believed in it and proved to others that aviation had a future." His legacy lives on through one of the fastest growing regional airports in the country.

8. CLEARED FOR TAKEOFF
The Akron-Canton Regional Airport

Canton's many small airfields and airstrips have added character to the aviation history of this area, but it has often been said that no community can grow without a viable airport. In the days before World War II, this region was about to receive the biggest advancement in transportation since the railroads were built in the 19th century.

Before the United States entered the war, Germany had already invaded several countries in the 1930s. President Franklin Roosevelt ordered the Civil Aeronautics Administration (CAA) to get America ready for air defense as war raged in Europe. The CAA was a division of the Department of Commerce and was given the responsibility of enforcing safety in aircraft construction, licensing pilots, regulating passenger rates, and assisting in airport construction through an act of Congress in 1938. In September 1940, the CAA allocated $500 million for a long-range plan to develop airfields across the country. Ohio was to receive $15 million for 104 airfields.

Perhaps because of the significant wartime contributions of its industries, and the possibility that they could become targets, Canton received $230,000 to begin initial work on development of a Class 2 airport, which would be capable of handling planes with no more than 20 passengers. The military needed an airfield in Stark County to act as a distribution center for new fighters and bombers, so the CAA approved $2 million for the construction of an airport near Canton. All the city had to do was provide the land. The military required three runways, each 5,600 feet long and 150 feet wide, on at least 800 acres.

Debate dragged on. The Akron-Fulton Municipal Airport, Martin Field, and various Stark County farms were considered. Finally in December 1942, city council voted to use $200,000 from the Timken war profit tax revenues to purchase land for the airport. The money was originally supposed to help pay for a sewage plant and repairs for the auditorium. Private contributions came from 10 industrial leaders who also contributed to the fund: Timken, Morgan Engineering, Hercules Motor Corporation, Union Metal, Brush Moore Newspapers, Hoover, Diebold, Tyson Roller Bearing Company, Republic Stamping and Enameling, and Canton Drop Forge.

But it was too late. The CAA was tired of waiting for Canton to make a decision, so it selected land in Summit County instead. The Canton Chamber of Commerce was dumbfounded. It tried to salvage the loss by proposing a bi-county effort between Stark and Summit Counties, only to discover that joint county ventures were illegal in Ohio. Legislation was introduced in March 1943 to change this law, but the measure failed. Luckily a Stark County businessman found an obscure law allowing joint county enterprises, so the state legislation was bypassed.

Again, the CAA and the Army were fed up with the delays in Stark County and President Roosevelt nixed the whole project. Four years had passed since his original request for an airport and no airport was started. After bombarding Washington, D.C. with phone calls of protest, the project was again approved six months later. Akron-Canton became one of 1,100 such airports commissioned by the federal government in that era.

The groundbreaking took place on October 6, 1944, on a 1,163-acre site on the Stark-Summit County line. Originally known as the Canton-Akron Memorial Airport, chosen to honor World War I and World War II veterans, the name changed several times in the early years. It was even briefly known as the Canton-Akron-Massillon Airport, before the name Akron-Canton Regional Airport was chosen. But the three-letter FAA designation "CAK"— C for Canton and AK for Akron—has remained from the first name.

By November 1945, the administration building, hangar access highway, and sewage systems were built. But the war was over, and there was now no need for a military airport in Stark County. The airport would have to change focus and become a center for passenger service. In February 1946, before it was even finished, four airlines announced plans to leave the Akron-Fulton Municipal Airport for Akron-Canton Airport, which would be able to accommodate larger planes on longer runways. Akron officials were not pleased, citing millions of dollars in revenue loss for their city. But the airlines were convinced the new airport would better serve them. Three 5,600-foot runways would be more than adequate to establish a thriving passenger service.

Construction continued, and by the following year the long-awaited airport was finally finished. Dedication ceremonies were held in October 1946. The airlines American, Eastern, and United landed large airplanes on the brand-new runways. Private planes were also housed at the new airport. There were 35 daily flights, and the airport served 92,000 passengers in its first year. The U.S. Weather Bureau also moved its offices from Akron-Fulton to Akron-Canton.

The airport was governed by an eight member board of directors, four from each county, as it is today. They are appointed by the county commissioners of their native county, and then approved by the other set of commissioners.

The airport experienced its first plane crash on December 28, 1948, at 7:58 p.m. Eastern Flight 758 lost its landing gear as it touched down and skidded down the runway. There were no injuries. The first fatalities happened almost a year later on November 4, 1949, when a twin-engine DC-3 crashed in a wooded area near the airport, killing three men.

A special air show marked the 50th anniversary of powered flight in 1953. It was the second-largest show in Ohio that year, and the biggest ever staged at Akron-Canton. Celebrating half a century since the Wright brothers took flight, the air show featured replicas of three famous planes. One was a boxkite "pusher" like the one the Wrights flew. A second was a World War I SPAD biplane, an exact copy of the one Captain Eddie Rickenbacker became an ace in several times over. And the third was a Pitcairn Mailwing like the one that started airmail service in 1928. Hercules Motors displayed several piston-type aircraft engines, and Standard Oil showed a 1903 horse-drawn tank truck. Thousands waited in line for as long as 45 minutes to tour the interior of an Eastern Airliner, a United Airlines DC-4 Cargoliner, a Navy PBY Catalina, an F-8 Bearcat, and many civilian aircraft. Admission to the event was free, and in total over 100,000 people attended, with over 600 taking advantage of air tours of the Canton and Akron areas.

Captain George Bleimes of the 166th Ohio Air National Guard Fighter Squadron added a bit of a thrill to the show when he crash landed in a hayfield west of the airport. Although most spectators did not realize he had crashed, Bleimes had engine and control trouble while in formation and made an attempt to land on the runway. Realizing that he was going too fast to stop before the end of the runway, he tried to go back into the air, but the plane did not respond. He emerged with only a scratch on his left wrist, but a small rabbit had been killed in the field upon impact.

Tragedy struck in 1955 at the opening event of another air show held on Memorial Day weekend at the airport. As a crowd of 2,500 looked on, a 29-year-old barnstorming pilot crashed to his death. According to an article in *The Repository*, "the speedy, clipped-wing Dart he was looping failed to pull out of a dive. It smashed nose-down into the edge of the paved, north-south runway." The pilot was Paul W. Anderson, who was on leave from his regular job with Pan-American Airlines. He was engaged to marry the daughter of the plane's owner, adding another level of heartbreak to the story.

Anderson and Frank "Buddy" Rogers had taken off in formation to perform dual maneuvers. They completed several snaprolls, slow rolls, and "Cuban eights" before attempting the inside loop. Observers that day said Anderson started his loop too close to the ground, and when he hit the peak of the loop at 450 feet in the air, his plane stalled and headed toward the ground. Had he started the trick at a higher altitude, he would have had more time to complete the loop.

His plane hit the runway, bounced 15 feet, and exploded in a massive fireball before landing on a pile of sod and catching it on fire. Volunteer fireman John Rumph of Greensburg put on an asbestos hood while other firemen wet him down. He ran into the burning wreckage, cut Anderson's safety belt, and pulled him from the inferno. Within 62 seconds, the fire was under control, but the pilot had been killed on impact. Almost every bone in his body was broken in the crash.

Surprisingly, the air show continued after the accident with two more acts that day. Rogers did his "ribbon cutting routine," where he dropped a roll of ribbon in mid-air and "kept darting back and forth through it, cutting it each time with the plane's prop." An old pusher type plane also went up, setting off a mock atomic bomb for the crowd. "Red" Grant did not parachute as planned because the ceiling was too low, and he had strained his back and ankle in a jump the day before.

In 1956, Akron-Canton became the first airport in the state to have an "air ambulance" to move patients over long distances as quickly as possible. Air Services Inc. purchased a twin-engine Cessna UC-78 and converted it for medical use. The plane was powered by two 245-horsepower engines, with a cruising speed of 145 miles per hour. It could travel a distance of 350 miles.

Since doors on a regular plane were not big enough to accommodate ambulance stretchers, the "air ambulance" was equipped with a specially designed door built into the rear of the fuselage, providing easy entry for cots. Once inside, the cots were locked into position to prevent injury during flight. Thomas H. Clemmitt, president of Air Services Inc., was the chief pilot, but George Heggy also flew the plane. Clemmitt's wife Erdine was a registered nurse who worked at Aultman Hospital, and was often on board to accompany patients on flights. The plane was also used as an "aerial hearse" to move bodies when needed.

Although today we can turn on The Weather Channel any time to see what weather is heading our way, that wasn't always the case. In 1957, H. H. Timken Jr. donated a $35,000 storm detection radar system to the

U.S. Weather Bureau for use at the airport. Made in London, the equipment was able to detect storms up to 280 miles away, covering an area of 30,000 square miles under average conditions. The new system was able to track rain and snow, and also spot the position, speed, and direction of storms. A news article proclaimed that the radar would provide early warning for severe weather, and would save lives. In 1977, the airport received an automated weather radar system, installed by the National Oceanic and Atmospheric Administration. It featured a protective plastic sphere over the antenna, allowing it to keep working during storms. The new equipment was also able to measure the height and intensity of a storm faster and more accurately than the older system. Although it would be primarily used for storm detection, the radar would also be used to gather weather information for pilots.

With industry and the economy booming after World War II, businesses began to use air travel as a regular company expense to visit new plants in faraway cities. With airplanes, travel time could be cut from days to mere hours. Industrial leaders had seen how the military had used planes to transport troops and equipment between countries during the war. Now they sought to harness the power of flight for business. By 1957, many prominent area businesses and industries maintained private hangars at the airport, including Firestone, Goodyear, Goodrich, Timken, Hoover, E.W. Bliss, Standard Oil, and Brush Moore Newspapers. Over the next ten years, several runway improvements were made but the airport could still not accommodate commercial jets, which were considered the wave of the future.

Over 15 years after the controversy surrounding the airport's construction, another public argument began to play out in the local press in 1958 when a group of aviation enthusiasts banded together in an effort to construct a municipal airport in Canton. They claimed Canton was one of only a handful of cities in Ohio without a municipal airport. A committee formed to explore the idea of developing one. The goal was a "home" for 30 aircraft owners who said they had no space nearby to store their planes. Some were using pasture lands or barns.

The committee quietly searched for locations and investigated possibilities for funding the venture, including a pitch to the Civil Aeronautics Administration. They discovered the city would be responsible for half the cost of any project funded by the CAA. Local aviator Ray Poorman charged that the growing facilities at Akron-Canton only provided increased tax revenues for Summit County, where most of the property was located

The Repository quickly jumped to the defense of the existing airport, citing that it was not overcrowded and should be adequate for "some years to come." On November 1, 1958, an editorial titled "One Big Airport Is Enough Now" read:

> Talk about possible plans for a municipal airport for Canton comes as something of a surprise, because there is no real need for a city airport now. . . . It is true that many cities in Ohio have municipal airports. But most of those cities do not have available county airports such as ours. Only in the largest cities of Ohio, where the prime airports are overcrowded, is there a real need for more than one public airport. Canton has not yet reached that stage of growth. . . . For safety and convenience in this growing age of flight, more and more airports are desirable. Thus some day the facilities at Akron-Canton may be overcrowded to the point where Canton would be forced to provide a municipal airport. But that day is not yet here, nor will it be in the near future. It would be wasteful of public funds to build another public airport so near one which is already more than adequate.

The editorial also suggested constructing more hangars at the airport to accommodate those private planes without adequate storage facilities.

Still the committee continued working on the idea of a municipal airport. Almost a year later, another *Repository* editorial revisited the issue with harsher words, saying, "Airports don't come cheap, especially on developed property. . . . It would open the possibility of giving the city government a white elephant to feed for the convenience of those who would like to have an airport closer than Akron-Canton but who would be in no position to underwrite its cost." The state would provide no funds, and the FAA was unlikely to assist because of the close proximity to the existing airport and the lack of an established need for a second airport. On September 2, 1959, yet another *Repository* editorial raised more questions about who would use the new airport. With improvements in the works at Akron-Canton, the airlines were not likely to transfer their operations. Even private fliers, they argued, would prefer the established services available at the existing airport. The editorial went on to say, "Canton does not have enough money to pay for its new City Hall, to pave its badly rutted streets, or, in fact, to operate as a modern city should be operated. It is out of the question to think of

the possibility of spending money it does not have for something it does not need." City Council did entertain the idea in a debate, but eventually it was abandoned and construction of a municipal airport never materialized.

Even in the midst of controversy, improvements continued at the airport. In 1959, ground was broken for a new terminal building to replace the "sheep shed" or "Quonset hut" that was now much too small for the number of people who were using it. In 1949, 97,748 people made use of the airport. Over the next decade, the airport served more people every year. By 1954, there were 164,659 people flying in and out of the airport. Better flight schedules on newer aircraft would mean even more people would be flying at Akron-Canton in the future. The restaurant was crowded into the southeast corner of the building, where there was reportedly barely enough room for a griddle, dishwashing space, and a counter with only 13 stools. Since more than 13 disembarked from a single flight, and several passengers were already in the airport waiting for connections, the tiny restaurant was grossly inadequate.

The new terminal was built 300 feet east of the old one, and covered the existing parking lot at that time. It was to be paid for in part by an FAA grant and revenue bonds in Summit County. The improvements dovetailed nicely with the predominant theme of the era: "Out with the old and in with the new." The 1950s were a time of dreaming about the future. Clayton G. Horn, executive director of Brush-Moore Newspapers, exemplified the times, saying, "No modern city can expand without an airport."

In 1962, the airport made further improvements with new radar and runway lights, and increased staff. With the terminal project completed, a $3 million state-of-the-art facility greeted travelers flying into and out of Akron-Canton. "Canton and Akron no longer need be ashamed of the facilities offered at the airport," proclaimed a *Repository* editorial. Airport advertising featured concrete parking lots, restful lounges, modernized check-in and baggage areas, quality dining services, moving sidewalks, and an observation deck. The new terminal was the first in the world with mechanized rubber belt ramps, called a "beltwalk," to transport passengers up and down between the two floors. They were 44 inches wide, 65 feet long, and moved people up and down a 12-percent incline. They were powered by electric motors and hidden pulleys under a flat, continuous rubber belt. Escalators were far more expensive, costing $1,300 per foot instead of $300 per foot for a beltway.

In its first decade, Akron-Canton saw improvement every year. When it first opened, air travel had been relatively expensive, and therefore exclusive.

As improvements were made in aviation, the cost began to come down, increasing passenger traffic. So-called "modern" planes offered a degree of comfort and convenience that had never been seen before.

But the airport was not growing as fast as some had hoped. Despite enhancements, passengers seemed to prefer Cleveland-Hopkins to Akron-Canton. Before the renovations in 1959, 89 percent of the travelers in Stark and Summit Counties were going to Cleveland. Afterwards, the number dropped to 70.7 percent. Cleveland had more flights and was easier to get to, especially for residents on the northwest side of Akron. What the Akron-Canton Airport needed was a highway.

Construction on Interstate 77 began in 1957. Funding for the project was split 90 percent from the federal government, 5 percent from the state, and 5 percent from the cities it ran through. By 1966, I-77 was completed, and the airport launched a marketing blitz to entice passengers to the facility. They mailed 200,000 brochures, gave out 100,000 free placemats to restaurants, and distributed windshield stickers with the message "Use Akron Canton—your nearest jet airport."

Prop-jet service began in 1959, during the terminal improvement project. A Capital Airlines Viscount could now carry 46 passengers to Florida in just four hours and 25 minutes, at an astounding 335 miles per hour. The flight was offered seven days a week, with a brief stop in Cleveland to pick up additional passengers. In an article in *The Repository*, Capital president David H. Baker said, "We of Capital are happy to establish two firsts for Akron-Canton. We'll have the first jet-powered takeoff and the first direct service to Florida. And there is a third first—the first jet flight to New York."

The "jets" landing at the airport in 1959 would be referred to today as turbo props, planes that still use a propeller for propulsion. To compete with the region's larger airports, Akron-Canton had to attract jet airliners. Aviation technology was changing so fast, new inventions were becoming obsolete almost before they were put into use. According to a *Repository* article from June 16, 1964, "A surprise came when jets supplanted propeller planes for long-distance flight. Airports like the Akron-Canton facility suddenly found themselves off the 'main line,' because the big new jets needed longer runways and more passenger traffic." The new medium range jets were well-suited to Akron-Canton, however.

In August 1964, a United Boeing 727 landed at Akron-Canton after a 13-minute flight from Pittsburgh, using just one-third of the 5,600-foot runway. United had brought the plane to Akron-Canton to train ground crews who would be servicing them when they landed beginning in October

1964 as an alternative to Cleveland-Hopkins. No regular jet service was scheduled at that time.

Shortly after the historic landing, *The Repository* editorial staff put the situation into perspective, "To draw a parallel—showing Akron-Canton's competitive situation with Cleveland-Hopkins—try to imagine how much business a car rental agency would do if it offered its customers 20-year old autos while its competitor provided 1964 models. Which do you think would rent more cars?" The editorial went on to say that the planes flying in and out of Akron-Canton were slower, compared to the "powerful new, whisper-quiet, vibrationless jets available at Cleveland-Hopkins."

In 1968, another historic "first" occurred when a non-stop flight to Las Vegas took 160 passengers on a United Boeing 707. The plane was the first to use the new 800-foot extension that had been built onto the north-south runway, making it a total of 6,400 feet long. Full operation of the lengthened runway was scheduled to begin in January 1969. Although the 707 could have landed on a 5,600 foot runway, FAA safety regulations required a longer stretch.

In 1970, Akron-Canton was proclaimed one of the safest landing fields in the country. With all the electronic and safety devices available at the time, the airport offered the same level of safety any major airport could provide. The airport's localizer determined the exact location of the center of the runway, and the glide scope kept the pilot informed of proper altitude while landing his aircraft. Located on relatively flat terrain, the airport featured "excellent approach characteristics." Field Maintenance Superintendent Robert Burdette was called one of the best in the country.

Over the years, snow removal has been a chief concern of the airport's maintenance crews. In the 1970s, Burdette and his crew operated four speed plows and a huge rotary broom with blower. The plows spread heated sand to melt snow, which created a sandpaper-like surface when it froze. Salt cannot be used to control snow and ice at an airport because it can damage an airplane's aluminum skin.

During this time, Jack Doyle served as the airport's manager. He had attended Rocky River High School and John Carroll University. He began flying at age 16, received his pilot's license in 1940, and flew during World War II. He had managed Burke Lakefront Airport in Cleveland for 15 years after the war, practically building it himself. He ran the first bulldozer across the former city dump that would become the airport and landed the first plane when the runway was completed. He was appointed commissioner of Cleveland airports in 1963, and came to Akron-Canton in 1968.

He cited several needs for the airport. First, there was no question that the preferred runway had to be extended to 7,000 feet. Second, the airport needed a cargo complex away from the terminal. Other needs included adding a second story to the service building, constructing a glassed-in subtower to increase efficiency of operations staff, and luring more major industries to build hangars at the airport. Finally, Doyle pointed out the need for an airport hotel, which would not come to fruition until 2006.

Doyle was optimistic about Akron-Canton's future, saying, "Cleveland-Hopkins is overcrowded now. There's no space available for expansion. We have an ideal location with great highway access minus congestion, with convenience air travelers won't find elsewhere. If we can provide facilities to accommodate the planes, we could give the airlines what they need and in turn get what we need in additional service."

Doyle was able to make several improvements in his first few years at Akron-Canton. In 1971, the Title Guarantee & Trust Company gave the airport 84 acres to construct a jumbo jet runway. The land was located in Stark County, between Wales and Frank Roads, along Mt. Pleasant Road. The proposed 7,000-foot runway would extend the 5,600-foot southwest-northeast runway. The new runway would be able to accommodate the new 300-passenger DC-10, and another 2,000 feet would mean a Boeing 747 could land at Akron-Canton. Doyle also oversaw the completion of a $260,000 sewage treatment plant, four new passenger holding rooms, a new $100,000 taxiway, two new parking aprons for aircraft, and a large hangar and flight operation center built by General Tire Company in Akron. He set a goal of 50 daily flights, compared to Cleveland-Hopkins's 400 flights per day, stating, "We have one of the finest facilities in the nation for our size."

Despite continued improvements, times were difficult for the airport and the aviation industry nationwide. In 1973, Doyle faced a possible 50 percent cut in the budget, which would create a domino effect throughout the facility. Fewer flights meant fewer customers in the airport restaurant and at the car rental facilities. No personnel cuts were planned, but an approved contract was revisited. Allegheny Airlines planned to reduce the number of daily flights from 14 to 4 after federally ordered fuel cutbacks became fully effective January 1, 1974. Eastern Airlines intended to eliminate all flights out of Akron-Canton. The airport filed a complaint with the Civic Aeronautics Board to stop Eastern from withdrawing service.

With passenger traffic down 10.9 percent in December 1974, Doyle said, "We are not bleeding now because we are holding our own, but it may get

bad. . . . We may have to reduce personnel or salaries. We have some serious problems." The only way to turn things around, airport officials believed, was to continue to improve the airport. Trustees approved a $65,000 contract for planning the runway extension. The FAA urged the airport to create a 9,000-foot runway and to equip it with instrument landing facilities for landing in bad weather. The extended length would increase takeoff and landing safety, and would allow the new jetliners to carry full loads for longer non-stop flights than was possible at that time.

Just five years after being declared one of the safest airports in the country, a *Newsweek* article ranked Akron-Canton on the top five list of most dangerous airports. Doyle attributed it to the runway length, and saw it as further proof that the airport needed to move ahead with the extension project. He pointed out that Dallas-Fort Worth had been deemed "safest" in the *Newsweek* article, and that the shortest runway at that airport was 12,000 feet. He noted that no scheduled airliner had ever been involved in a fatal crash at Akron-Canton.

With the expansion plans in motion in 1975, not everyone was thrilled with the progress. A public hearing was held to air the grievances of those who opposed the extension of Runway 23. The crowd was extremely vocal, often talking over the engineers presenting their plans. Mostly neighbors were concerned about noise, with a few worried about safety issues. They displayed signs with slogans like "Akron-Canton, who invited you to my barbeque?" *Repository* reporter Betsy Williams wrote, "It was stressed that the airport was constructed in 1946, prior to much of the residential building that has taken place in Jackson Township, and that, despite the airport, the township has become the fastest growing community in the nation."

Over its first 30 years of existence, the airport had drastically increased its operations, as demonstrated by the career of one of its employees. In 1976, air traffic controller Philip Gizzi, who had come to the airport in 1948 shortly after it opened, announced his retirement. He recalled that only 10 people worked with him in the tower when he began, and nearly three decades later there were over 40 on staff. He had been on duty the day the airport experienced its first crash, on his first day of work.

Gizzi noted that as the type of aircraft changed, his job got much more complicated. He told *The Repository*, "Speed has quadrupled over the years. The system has more airplanes in it—higher speed aircraft—so you have to have more know-how today to do the job. We've got sophisticated equipment—radar, automatic transponder beacon equipment, and so much additional gear that the controller has to learn more."

In a more recent interview, Gizzi explained the difference radar made to air traffic controllers. "Before radar, in order to keep planes separated you used time and altitude," Gizzi said. "You kept each plane separated by 1,000 feet, and planes at the same altitude were kept 10 minutes apart at level flight. With radar, you could have two or more planes at the same altitude separated by just three miles. You could have more in a confined airspace because you can see them on the radar scope. Radar gives you more time to make decisions about what you want to do with the airplanes." In the days before radar, it also took longer to get planes in and out, because you had to wait for a plane to climb to a certain altitude before the next one could take off.

More changes were yet to come. In 1978, government deregulation of the industry allowed airlines to set their own schedules for the first time in 40 years. Previously, the Civil Aeronautics Board had controlled ticket prices, assigned the routes each airline could fly, and established flight schedules. Originally the plan was designed to help a fledgling industry stay afloat in the early days of aviation. In the 1930s, many start-up airlines were going bankrupt, creating instability in an important new transportation industry. Understanding the significance of aviation to the future of travel, the government created the Civil Aeronautics Board to stabilize the industry. The CAB dictated the times and destinations of all commercial domestic flights, insuring that all areas across the country were provided with access to air travel. For example, one airline might be required to provide service from Flint, Michigan to Chicago, a route that would always lose money, but in exchange it would be the exclusive carrier for a popular destination such as Chicago to Hawaii. In 1978 leading economists advised the deregulation of the industry to allow for competition among the airlines, which they believed would benefit the consumer. At regional airports like Akron-Canton, the immediate effect of deregulation was devastating. Airlines were no longer required to provide service to smaller airports and reduced the number of flights or left for larger markets.

The airport continued to struggle in the 1980s with the recession and an air traffic controllers strike. Deregulation of commercial aviation encouraged major airlines to move operations to high traffic points. The future looked bleak. The economic slowdown of the 1980s brought difficult times for airports around the country. Akron-Canton was running as lean as possible, while still serving the public. Frederick Krum, who was then manager of the airport, said, "We're not eating steak. But we're not missing any meals." He cited the fact that "fun flying" had all but disappeared because of the

recession, and its effects were rippling through the industry. The cost of jet fuel skyrocketed, making it difficult for airlines to operate.

In 1981, Krum was promoted to airport director, becoming the youngest director of any commercial airport in the country. A graduate of John Carroll University and the University of Akron School of Law, he certainly had his work cut out for him. "Bad times got worse," he said. In an attempt to revitalize the airport, Krum initiated a series of expansion projects that were the largest in its history. In the 1980s, $15 million was spent to expand the airport. Krum received a $2.1 million grant to extend the main runway 2,000 feet, which had first been proposed almost 20 years earlier. Two-thirds of the cost went to four million cubic yards of fill dirt that was needed to level the hilly terrain. The longer runway allowed airlines to offer non-stop flights with full payloads of passengers, fuel, and luggage to places like Chicago and Atlanta. The new extension created a 7,600 foot runway that was completed in 1986. Officials also added a new loop road and larger parking lots. The short-term spaces increased from 40 to 240, and long-term parking added another 150 spaces to make 1,100.

In 1989, Krum unveiled a massive strategic plan at a luncheon at the City Club of Canton. A proposed $46 million would be poured into airport improvements, ranging from increased runways to an overhauled terminal building. Krum said the FAA would cover 70 percent of the cost, which is generated by airline ticket taxes directed to a fund for airport improvement grants. He argued in a July 20, 1989 article in *The Repository* that it was not airline deregulation that caused problems in the industry, but rather "too many airplanes and not enough runways and airports to handle them. . . . What we've got to do is expand the airports in this country, and that takes a lot of political and social will."

Most people agreed that a bigger airport would serve the Canton/Akron area better. Most people, that is, except for the airport's neighbors, some of whom had argued against expansion plans in the 1970s. Air traffic noise does increase as airports expand, and not everyone liked that idea. But the improvements were necessary if the airport was going to increase its share of the market. Passengers are attracted to airports that appear progressive, so the terminal desperately needed a facelift.

In the 1990s, the airport existed in the behemoth shadow of Cleveland-Hopkins. It lost several major carriers, and those that chose not to leave significantly reduced their services. Three airlines ran a scant 27 flights per day. The airport needed a new direction to capture a larger slice of the pie, so the staff made a conscious decision to retool their product to suit the market.

They looked for their niche and aggressively marketed it. *Akron Beacon Journal* writer Mary Ethridge described it as a "textbook example of a marketing success for northeast Ohio." The airport began to use its reputation as "second fiddle" to its advantage. They said yes, our airport is small, but it is also easier to navigate. Pointing out those kinds of "weaknesses" and turning them into strengths was the root of the late 20th century marketing campaign.

And it paid off. In 1996, the airport had 4 percent of the regional air passenger market. By 2005, that number had increased to 10 percent. In the mid-1990s, most area residents had the perception that the fares from Akron-Canton were too high and the planes were too small. Unfortunately, this perception was accurate. Kristie Van Auken, director of marketing and communications at Akron-Canton, told Ethridge "Price is now the number one motivator for passengers. At that time, we couldn't compete on that front." The airport began searching for a stronger product.

A turning point came in 1997 when the airport attracted AirTran Airways to its facility. The airport had experienced a surge in the late 1980s when low-fare carrier Florida Express started flying out of Akron-Canton. After Florida Express pulled out, the airport staff began to focus on attracting another low-fare carrier to create the kind of service that would sustain long-term growth. AirTran was the perfect answer to the airport's lingering problems.

AirTran's fares were hundreds of dollars less than its competitors, to popular destinations like New York. People were not used to fares so low, and they flocked to the airport's newest airline. Right away, AirTran offered non-stop flights to Orlando, Atlanta, Tampa, New York, and Boston. The fares were the lowest average fare of any airport in Ohio, Michigan, Indiana, and Pennsylvania, according to industry statistics. "Momentum in any business is critical," Krum told business writer Todd Shyrock. "It makes doing the next thing that much easier. It doesn't keep rolling around by itself. There are always speed bumps, and you have to make the next lunge."

AirTran was taking a significant risk when it signed on with Akron-Canton, and airport officials knew they would have to work hard to keep the airline happy. VanAuken said the airport had to begin marketing to get "butts in the seats for them." They exploited the benefits of a smaller regional airport: cheaper parking, shorter lines, quicker hikes to the gates. All of these things combined into one package—a lower-cost, hassle-free alternative to the "big guys."

People really responded to the new marketing strategy, and business began climbing. Just as Akron-Canton was poised to capitalize on its efforts in the late 1990s, along came another bump in the road. After the September 11,

2001 terrorist attacks, air travel came to a sudden halt. Krum described what happened at Akron-Canton that day: "We were advised that the skies were being shut down and we should expect up to 50 planes to make emergency landings here." Only six planes landed, but the airport was prepared to accept many more. One was an American Airlines 757. As the captain of that flight watched events unfold on CNN with Krum and his staff, he said, "Right now Akron-Canton is a good place to be." Krum responded, "Sir, every day is a good day to be at Akron-Canton."

Airspace was closed for three days, leaving displaced passengers and crews across the nation. The entire country was under military aircraft cover, and no one was sure if more attacks were planned. "It was a scary time," said Krum. "We went into crisis mode." Everyone knew security was going to be totally different than it had been in the past, and Akron-Canton had a significant issue concerning the proximity of the parking areas to the terminal. It was not clear who was a likely target, and how a potential attack might be carried out.

Without a doubt, September 11 was a significant impediment to the airport's success. But to Krum, it was just another hurdle to jump over. "I'm not paid to give up," he said. And he didn't. "My job is to believe you can do it, even though all conventional wisdom says you can't." The industry is notoriously erratic, falling prey to every kind of disaster from economics to high-profile crashes. Although September 11 was far greater than any previous setback, Akron-Canton and the rest of the airline industry had bounced back from tragedy before. There had been the Value-Jet crash, the fatal malfunction of a Delta engine, and the TWA explosion, just to name a few.

Planes were flying again within a week of the attacks, but there were far fewer flights serving a reduced number of passengers. But Akron-Canton rebounded far faster than the national average, returning to normal levels by mid-November. Statistics showed that the numbers for the second half of November 2001 were the same as the second half of November 2000.

The airport began advertising within two weeks of September 11. Again, the marketing team built upon the strengths of the airport. Increased security meant horrendous lines and long waits at the larger airports. At Akron-Canton, passengers could be processed more quickly, significantly reducing wait times. A smaller, less anonymous airport suddenly seemed safer. The airport continued moving forward, despite the obvious setback, waiting for the public to regain confidence in air travel. Increased FAA security measures helped to win back customers, but it didn't happen overnight.

Not being the kind of business that sits around waiting for something to happen, Krum and his team began working harder than ever to promote the airport as a viable alternative to their competition. After Delta came to the airport in 2001, Akron-Canton purchased billboards right near Cleveland-Hopkins and doubled its advertising budget. Marketers introduced "Oscar," an inflatable punch dummy, in a new advertising campaign and adopted the slogan, "A better way to go." In the television commercials, Oscar is seen being thrown around by the crowds at the busy check-in areas of a large airport, squished into a narrow seat on a small aircraft, or stuck on an endless people-mover sidewalk to a remote parking lot where his car is presumably parked.

As the industry continued to recover from September 11, many airlines were forced into bankruptcy in the early 21st century. But in 2004, AirTran was one of only three U.S. airlines that posted a profit. The relationship between AirTran and Akron-Canton continues to be a good match.

Historically, the airport has also encouraged business interests in the area by providing hangar space to store corporate aircraft for Timken, Goodyear, B.F. Goodrich, Smucker's, and others. Some businesses have even relocated to the area because of the proximity of a quality airport.

In 2001, Krum unveiled the STAR program, or "Soaring with Terminal Access and Runway Improvement." This five-year plan included doubling the size of the baggage claim area and increasing the food court. But the signature project of the STAR program was constructing a new atrium and gate concourse that has placed the Akron-Canton airport in the same league as any major airport in the country. The entire plan cost $36 million, which was funded by FAA grants and the $4.50 facility charge per passenger.

Continued improvements have paid large dividends in a challenging market. A third runway expansion was completed in 2003, which added an additional 1,200 feet to the 1968 runway expansion. The new length was now 7,600 feet, with runway safety areas of 1,000 feet on either end. In 2010, the airport expects to complete another runway extension that will add 600 feet to the 1986 project.

On November 12, 2003, Akron-Canton welcomed its one-millionth customer. Larry Lash, an independent business consultant, had flown into town on AirTran Flight 202 from LaGuardia in New York and was greeted with celebratory fanfare. Lash said, "I sometimes feel as if I've personally passed through this terminal one million times. This is a great day for this airport and community. A viable airport with great fares helps businesses like mine grow."

Progressive business acumen led to the one millionth customer celebration. Expansions within and without have added to the airport's recent success. It has continually purchased land around its facility for three reasons. First, for noise abatement. If the airport owns the land closest to its runways, no residential complexes will sprout up in those areas in the future. Second, to better comply with altitude encroachment policies, such as the height of trees. And third, to provide space for general development of the airport.

In 2006, Krum cited forward-thinking teamwork as the reason he was able to turn the airport around. "It really starts with having a vision, assembling the right team of people to do it, then executing," he said in an article for *Smart Business*. Krum believed risk-taking was the only way to move forward, and he encouraged his staff to nurture new ideas. "People fear failure. I got rid of that fear. I taught them that if they fail, I'm the one that will be the fall guy. No one will be left hanging out there on their own."

Many people do not understand that if the airlines have a problem, the airport shares the problem too. Krum said, "I think more than any other airport in the country, we are the marketing arm of the airlines. If we do not have good airlines with good service and low fares, people are not going to come down from Avon Lake just to have a Subway sandwich at the airport."

Recently, a group of local aviation enthusiasts banded together to honor the history of aviation. In honor of the 100th anniversary of the Wright brothers' flight in 2003, the Akron-Canton Aviation Park was dedicated. The project features an exact replica of the Wright Flyer, created from original plans and drawings obtained from the Smithsonian. Phil Gizzi was part of the project, which began in 1995 with some money left over from an air show. "We wanted to build a memorial of some sort," Gizzi said. "Someone suggested we use the Wright Flyer." They worked toward a goal of celebrating the centennial of flight, fundraising and writing grant requests for several years.

Two walls of honor near the replica plane showcase people who were instrumental in building the airport, or pushing it along over the years, as well as the names of famous aviators from this area. The Wright Flyer's nose is slightly elevated and one wing is tipped just a little, and it is 12 feet off the ground, just like the famous photograph of the first flight. "We made it as close to the original scene as possible," said Gizzi. The Aviation Park is a wonderful tribute to Canton's past, present, and future in aviation.

Canton's pioneers in flight would truly marvel at both the technological innovations in aviation and the growth of our local facilities. From a few

grass airstrips around town to the third-fastest-growing airport in the United States, Canton has seen many changes over the past 100 years. It would be difficult for the Aero Club of Ohio members to comprehend today's landscape if they could float over the modern countryside in their balloons. Transatlantic flights, far grander and faster than Walter Wellman's failed attempt, are commonplace in our global economy. William H. Martin's revolutionary monoplane design is the world standard in aircraft design, and Bernetta Miller's impossible dream of becoming a female commercial pilot is now a career choice for all women. All of Canton's pioneers in flight were visionaries who dreamed of a future filled with possibilities beyond anything they could imagine. Few communities can claim so many extraordinary individuals who challenged themselves to reach heights ever higher, freeing their minds and letting their dreams soar.

"A Man Can Fly, So Why Can't I?" *Fort Wayne Sentinel.* October 2, 1912.

"Air is Free; But Not Airports." *The Repository.* August 25, 1959.

Allen, Catherine Wallace. "Wright Military Training at College Park in 1909." *Air Power History.* Winter 2002.

"Atwood May Attend Canton Aviation Meet." *Newark Advocate.* August 24, 1911.

"Aviatrix Who Will Be Air Marshal of Suffragette Marchers." *The Racine Journal-News.* February 4, 1913.

"Balloonists at Oil City." *New Castle News.* January 29, 1908.

Beck, Laurel. "Canton aviation pioneer's glider comes home." *Massillon Evening Independent.* August 12, 1981.

"Big Balloons Off as Crowd Cheers." *Indianapolis Star.* September 18, 1910.

Bird, Mrs. Herbert A. Letter to Paul Garber. August 5, 1983.

Brown, Gary. "Sane people took a train." *The Repository.* February 20, 1984.

—————. "Ray Poorman developed career as a master metalworker." *The Repository.* June 24, 1984.

—————. "Canton man was an aviation pioneer." *The Repository.* December 12, 1988.

Caci, Carolyn. Personal interview with author. August 22, 2006.

"Canton Aviation." *Mansfield News.* September 26, 1911.

"Canton Will Have Real Air Ship Tourney." *Newark Advocate.* August 16, 1911.

Carringer, Helen. "Canton's Pioneer Pilot Recalls Busy, Happy Life." *The Repository.* February 17, 1963.

Chandler, Charles De Forest and Frank P. Lahm. *How Our Army Grew Wings.* New York: The Ronald Press Company, 1943.

"City Airport Answer Will Be 'No.'" *The Repository.* September 2, 1959.

"Daring Flights in Air Gain License." *Fort Wayne News.* September 21, 1912.

DeMio, Terry. "Airfield caught in nose dive." *The Repository.* February 2, 1998.

"Ely Takes Tumble at Canton." *Van Wert Daily Bulletin.* September 28, 1911.

Etheridge, Mary. "Right Marketing, pricing let airport spread wings." *Akron Beacon-Journal.* April 3, 2005.

"Excursion Train Runs into Cars." *Evening Telegram* (Elyria, OH). September 28, 1911.

Gizzi, Phil. Personal interview with the author. May 15, 2007.

Heald, E. T. *The Stark County Story, Volume 3*. Canton, Ohio: Stark County Historical Society, 1952.

Hettich, John. "Americans Did Fly." *Aero Digest*. December 1946.

"Historic Glider is now 'home' in Canton." *The Repository*. August 19, 1979.

Hungerford, Edward. *Timken at War*. Canton, Ohio: Timken Roller Bearing Company, 1945

"Interest Increases in Details of America's Flight Made in 1910 by Former Cantonian." *The Repository*. July 27, 1919.

Keller, Jim. Personal interview with the author. May 10, 2007.

Krum, Frederick. Personal interview with author. February 21, 2007.

Kuter, Gen. Laurence S. "Maj. Gen. Frank Purdy Lahm." *Air Force Magazine*. September 1979.

Lahm, Frank P. Letter to Stark County Historical Society. September 1960.

Lahm, Frank S. Unpublished autobiography.

Lahm, Larry. Personal interview with author. December 21, 2006.

Laston, Frank. "Aerial Stuntmen Recall Early Antics." *The Repository*. October 2, 1960.

————. "Airport's Terminal Keeps Things in Turmoil." *The Repository*. February 20, 1955.

————. "Florida Just 4½ Hours Away with New Akron-Canton Flight Service." *The Repository*. December 11, 1959.

————. "History of Akron-Canton Airport Is Story of Controversy." *The Repository*. May 24, 1953.

"Lieutenant Lahm—The American Balloon Racer." *The New York Herald*. July 2, 1911.

Mabley, Edward. *The Motor Balloon "America."* Battleboro, Vermont: The Stephen Greene Press, 1969.

"Man Who Tried 1910 Ocean Hop Was Repository Editor." *The Repository*. October 16, 1960.

Marson, Alice Young. "After all these years, the Akron-Canton Airport reaches new heights." *Senior Focus*. September 1992.

Martin, William H. III. Letter to Gervis Brady, Director of Stark County Historical Society. October 25, 1976.

McCrea, Lester H. "Early Birds Here Gave City Plenty of Thrills, Spills." *The Repository*. October 4, 1953.

————. "Many Natives of Canton Found Success in the Skies." *The Repository*. October 18, 1953

————. "Sherrick Gave Wings to Aviation on Canton Scene." *The Repository*. October 11, 1953.

Miller, Bernetta. "First Monoplane Flights for the United States Government."
October 1962.

—————. "How I Learned To Fly." *The World Magazine*. December 2, 1928.

—————. Letter to Helen Carringer. January 11, 1963.

—————. Letter to Joseph A. Markley. May 10, 1963.

Miner, Riley P. "Canton Needs Airport Pilot Says." *Canton Daily News*. June
3, 1928.

Pierce, Major Preston E. "Bernetta Adams Miller: Education, Humanitarian,
and 'Early Bird.' " *The Ghost Writer*. January 2002.

Pruitt, Bettye H. Timken: *From Missouri to Mars—A Century of Leadership
in Manufacturing*. Boston: Harvard Business School Press, 1998.

"Rough 90 Miles By Balloon." *New York Times*. April 25, 1909.

Semmler, Edward R. "Airport lives by health of airlines." *The Repository*.
August 26, 1996.

Sherrick, Johnson. "Aero Club Known Across the Seas." *The Repository*.

—————. "Scenes During Canton Aero Club's Ascensions, and Some
Prominent Members." *The Repository*. September 5, 1909.

Shyrock, Todd. "Taking Off: How Fred Krum turned the Akron-Canton
Airport into a flying success." *Smart Business Innovation in Business
Conference*. September 2006.

"Sky Pilot Up in Ohio." *Washington Post*. August 9, 1908.

"Skywriter Needs Plenty of Space." *The Repository*. October 2, 1949.

Still, Steve. "The Flight of the America." *Oakland Tribune*. October 9, 1960.

—————. "Bizarre Flight Wrote Aeronautical History." *The Repository*.
Oct. 9, 1960.

"Study Made of Municipal Airport Here." *The Repository*. October 31, 1958.

"Tells Why He Left Flyer—Walter Wellman Places All Blame on the
Equilibrator." *The Mansfield News*. October 20, 1910.

Timken Company. "Application of Anti-Friction Bearings to Airplane
Wheels." January 1930.

—————. "Scientist Invents New Steel To Boost U.S. Airplane Ceilings!"

"Walter Wellman is Off on His Trip Across Ocean in Airship." *Reno Evening
Gazette*. October 15, 1910.

Wellman, Walter. *The Aerial Age*. New York: A.R. Keller & Company, 1911.

"Wellman At Last Flying Over Ocean." *Lincoln Evening News*. October 15, 1910.

"Wellman Far Out Over Ocean." *The Daily Courier* (Connellsville, PA).
October 17, 1910.

"Wellman, First To Try Flight Across Atlantic, Is Dead." *Lincoln Star*
February 1, 1934.

"Wellman, Former Cantonian, First Trans-Atlantic Dash." *The Repository.*
 July 13, 1919.
"Wellman Is Still Alive." *Fort Wayne News.* October 18, 1910.
"Wellman's Party Makes New Record." *Manitoba Press.* October 19, 1910.
"Will Light from Skies—Miss Miller May Enliven the Pageant of Suffragists."
 Washington Post. January 15, 1913.
"World's Record in Volplane Landing." *New Castle News.* September 27, 1911.
"USAF—A Real Veteran at 17." *Pacific Stars & Stripes* (Tokyo). September
 19, 1964.